IMAGES
of America

DEERFIELD BEACH

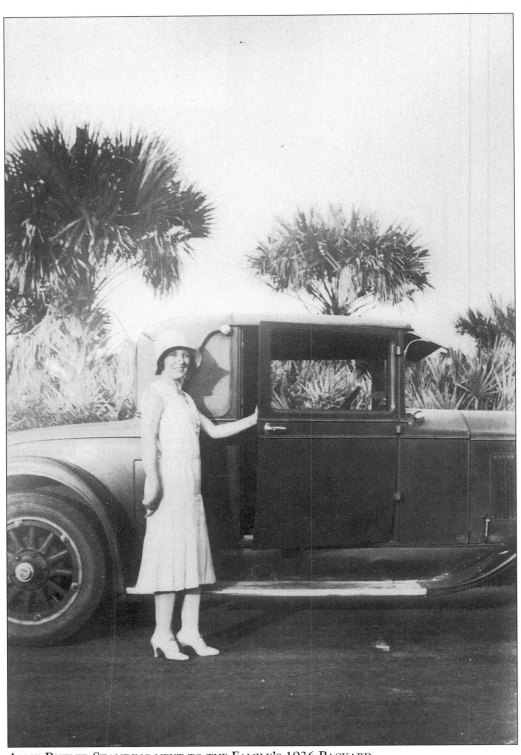

ALICE BUTLER STANDING NEXT TO THE FAMILY'S 1936 PACKARD.

IMAGES
of America

DEERFIELD BEACH

With love, thank you for everything

Dale Allen

Dale Allen and Rick Capone

ARCADIA

Published by Arcadia Publishing,
an imprint of Tempus Publishing, Inc.
2 Cumberland Street
Charleston, SC 29401

Printed in Great Britain.

Library of Congress Catalog Card Number: 00-107235

For all general information contact Arcadia Publishing at:
Telephone 843-853-2070
Fax 843-853-0044
E-Mail sales@arcadiapublishing.com

For customer service and orders:
Toll-Free 1-888-313-2665

Visit us on the internet at http://www.arcadiapublishing.com

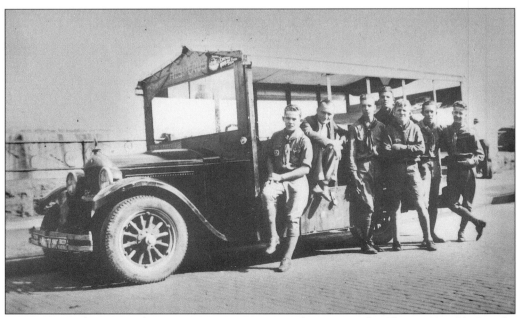

ROAD TRIP. The Broward County Boy Scouts prepare for a trip to the Chicago World's Fair for Scouts Day in 1933. Their method of transportation was a converted "Hupmobile," which could sleep eight on built-in bunkbeds. Pictured, from left to right, are Bobby McCan, Mr. ? Jacobs, Jack Butler, Frank Charlton, Philip Charlton, Webster Heith, and unidentified. (Courtesy of Jack Butler.)

CONTENTS

Acknowledgments 6

Introduction 7

1. 1890–1909 11

2. 1910–1919 17

3. 1920–1929 23

4. 1930–1939 41

5. 1940–1949 45

6. 1950–1959 53

7. 1960–1969 67

8. 1970–1979 101

9. 1980–1989 113

10. 1990–Present 121

ACKNOWLEDGMENTS

The authors would like to thank the following people for their contributions to this book:

For the use of their photographs the authors would like to thank the Deerfield Beach Historical Society, Margaret Briggs, Jack Butler, David Eller, Barbara Friend, W.S. Fullins, Charles James, Bob Skuggen, Judy Wilson, and Col. Robert Arnau (U.S.A.F. Ret.) who sent us his family's collection of the 1928 hurricane photos taken by his mother, Leona Meeks Arnau.

For helping ensure the accuracy of facts contained in this book, a big thanks to Susan Allen, Jack Butler, Ed and Doris Dietrich, Mary Mowry, and Margaret MacDougald Shadoin and Ed Shadoin.

Dale Allen would like to give a special thanks to his wife, Susan, and his children, Lara, Margaret, and Scott, for their encouragement while he was working on this project.

Rick Capone would like to give a special thanks to his dad, Felix, for all of his support, and for putting up with him and his writing dreams all these many years.

And the biggest thanks of all goes to all of the people of Deerfield Beach, past and present, for making this city the beautiful and wonderful community that it is today. Without the people who started it all, and without the people living here today, Deerfield Beach would not have a future. The people of the city have made it the great place that it is and will make it even better in the years to come. Thanks to each and every one of you.

We hope you all enjoy this book.

If you have any information or memorabilia relating to Deerfield Beach that you would like to share with your community, please contact the historical society at the address listed below. Preserving our hometown history is an ongoing project, and your assistance is always welcome. If you have any comments or questions, please feel free to write us at:

Deerfield Beach Historical Society
P.O. Box 755
Deerfield Beach, Florida 33443

or email us at:
fdallen49@earthlink.net
racapone@ix.netcom.com

INTRODUCTION

The year 2000 marks the 75th anniversary of the incorporation of the City of Deerfield Beach.

While the city celebrates its anniversary at the start of the new millennium, it seemed appropriate to take a moment and look back at the history of this quiet, seaside community. And it was that thought that sparked the idea for this book.

As with most places in the United States, the first settlers in the area were Native Americans; in particular, the Tequesta Indians can be traced back to the 16th century, while the Seminole Indians were roaming the area in the late 19th century. According to historical records, by 1898, there were about 20 to 30 pioneers settling along the banks of the Hillsboro River in what was then called Hillsborough. The area's name originated from the Earl of Hillsborough, who had received large land grants from King George III during England's hold on the region between 1763 and 1783. In 1897, C.E. Hunt, an engineer working on the Flagler railroad, renamed the settlement Deerfield because of all the deer in the area.

Some of the first recorded names in the community were Blackwelder, Jenkins, E.A. Thomas, Charles Arnold, J.C. Holley, John Saxon, Charles Smoak, John B. Thomas, and Young Tyndell. At that time, barefoot mailmen were delivering the mail along the coast of Florida, and Deerfield was one of their stops. In fact, in what was then Deerfield, the only barefoot mailman to lose his life while delivering the mail drowned while trying to swim across the Hillsboro Inlet. James Edward "Ed" Hamilton, a substitute mailman, was 33 at the time and just getting over being sick. When he reached the Hillsboro Inlet after a week of storms his row boat had been borrowed and left at the far side of the inlet. He tried to swim across, but he never got there. His mail pouch was found hanging on the limb of a seagrape tree. Searchers said that the inlet was teeming with alligators. The year was 1897.

It was in the spring of 1896 that Henry M. Flagler decided to expand his railroad down the coast of Florida, first to Miami, and then later to Key West. When it was completed at the turn of the century, farmers were able to ship their crops on the railroad, making Deerfield a solid farming community. Early in its history, pineapples were the key crop. Later other crops, especially tomatoes, would become important for the farmers in the area.

In 1898, the first post office was established in Deerfield, and John B. Thomas was named the town's first postmaster. In October 1903, Ardena and Joel Horne left their home in Central Florida and came down to the Deerfield area to visit her brothers who farmed in the area. Joel, also a farmer, saw a great opportunity in the area, and the couple, along with their two children, decided to stay. In that first year, a killer frost destroyed their pineapple crop, but Joel was not to be deterred. He tried other crops like tomatoes, peppers, beans, corn, cucumbers, and

eggplant, and with time, became very successful.

By 1910, the intersection where Hillsboro Boulevard and Dixie Highway stands today became the hub of the town's business district. The town had four or five stores, a post office, and two hotels, the Australian and the Pioneer. In 1911, the Hillsboro River was dredged and became a canal linking up with Lake Okeechobee, some 45 miles to the northwest. The project opened up more business opportunities for the farmers and the town, and a large celebration was held by the townspeople on December 14, 1911, to honor the canal's completion. While the canal was an important step in the town's growth, Ardena Horne recalled what the river was like when she first arrived. "Before the river was dredged, the water was as clear as glass," she said. "We even drank from it."

It was during the decade between 1910 and 1919 that other families who would become important in the development of the city began to arrive. J.D. Butler, G.E. Butler, W.S. Gaskin, and Walter L. Sweat, and Joel Horne, to name just a few, settled in the town. W.S. Gaskins and Walter Sweat opened grocery stores in the town's business district.

Around the middle of the decade, the pineapple industry collapsed. With the railroad reaching Key West, it was hard for local growers to compete with the Cuban pineapples being shipped by ferry to Key West. The farmers would have to learn to grow other crops.

In 1914 Deerfield received its first phone line, which was extended to Deerfield from Delray Beach. In 1915, Broward County was established, and Deerfield became part of it. In fact, during its short history, Deerfield was part of three counties. In 1903, Deerfield was part of Dade County. In 1909, Palm Beach County was created and Deerfield became part of that new county. Then in 1915 it became part of Broward County. Ardena Horne said "We lived in three different counties without moving from our house."

In 1917, the first bridge was built across the intracoastal waterway, giving residents and visitors easier access to the beach. Prior to that, beach lovers had to swim or use a boat to get to the beach. The bridge had a wooden floor and was opened using a hand crank to let boats pass through.

World War I hurt the farming community of Deerfield as winter crops were considered a luxury, and space in the freight trains heading north was used for military goods and by sugar-mill machinery shipped from Cuba. Also, a severe freeze in 1917 destroyed most of the tomato crop and, as a result, killed a project that would have built a processing plant in the town.

In 1919, a Women's Club was organized with an initial membership of 21 women paying 10¢ a month in dues. One of the club's first projects was the construction of a pavilion on the beach near the present fishing pier, which was then used for dances and picnics. To this day, the enlarged pavilion north of the pier is still used by the community for social activities. In 1923, there were only two or three homes on the beach. At that time many people did not see the "lure of the beach." It was mostly sand and you couldn't plant crops on sand. In the next few decades that attitude would change dramatically.

On June 11, 1925, with the town of Boca Raton threatening to annex Deerfield to gain control of the beach, the town's leaders, led by J.D. Butler, incorporated and established the new town of Deerfield. A mayor-council form of government was set up, and George Emory Butler was named the town's first mayor. In the year 1925 the town's first library was opened by the Women's Club and was operated from the home of Mrs. Lee Craig.

The town hit a stretch of bad luck starting with a hurricane that struck in 1926. Just as the area was recovering from that hurricane, an even bigger hurricane struck in 1928 and leveled most of the town. Then in 1929 the Depression hit, and Deerfield closed out the decade struggling more than the rest of the United States.

During the late 1920s and early 1930s, William L. Kester built bungalows on the beach and along Hillsboro Boulevard, which provided jobs and low-income housing for people. An example of a Kester cottage, or Pioneer House as it was originally named by the Deerfield Beach Historical Society, is now located next to the Butler House Museum, home of the Deerfield Beach Historical Society.

The Depression hurt a lot of people in the town. According to J.B. Wiles Jr., a businessman who arrived in Deerfield in 1925 and who also served in many city and county posts in his life, it was a tough time. "Many people just abandoned their homes and lots," he said. Still, by the end of the decade, the town's population was close to 1,500.

In the 1930s, Deerfield was also struggling with prohibition like the rest of the country. All along the Hillsboro Canal, rumrunners had numerous unloading sites and federal agents did occasionally capture a boatload of liquor. At one time, Al Capone's lawyer looked into buying land on what has been called Capone's Island and is now Deerfield Island Park. He never went through with it.

In 1937, Bill Stewart's uncle purchased a building in the eastern part of town that was once a packing house for produce and seafood. He remodeled it and in 1938 opened the Riverview Restaurant and Lounge as a private gambling club. The club catered to clientele from the Boca Hotel and the Hillsboro Club. On August 22, 1939, the town of Deerfield changed its name once again, to Deerfield Beach. The population was around 1,800.

It was in the early 1940s, with the start of World War II, that the city began to grow. With the construction of an air base in Boca Raton, where Florida Atlantic University now stands, the need for housing and services increased and Deerfield Beach was able to provide them. With the start of the war, the east coast of Florida became a prime target for enemy submarines on the prowl for U.S. ships. A watchtower was built on Deerfield Beach and manned 24 hours a day by volunteers. According to J.B. Wiles Jr., "Sometimes you could stand on the beach and see six or eight U.S. ships burning at one time because of the enemy subs." During the war, those volunteers were instrumental in helping to capture a number of submarines, and on one occasion, troops from Boca Raton captured six German spies trying to come into the Hillsboro Inlet on rafts.

At the end of the war, tourists began to discover Deerfield's beautiful beaches, and hotels and motels began to spring up. But in 1947, a hurricane slammed into the coast causing much damage to the beach and the buildings. At that time, Deerfield Beach extended two blocks farther east than it does today, with a street running parallel and to the east of A1A. That land now lies under the Atlantic Ocean.

The year 1947 marked the start of the town's first civic organization, the Lions Club. The group's first project was to build a public park, which was called Pioneer Park. To raise funds to clear the land and create the park, the club held several barbecues, which became so popular that the barbecue became an annual event at the end of each April. The celebration became known as "Cracker Day." Its purpose was not only to honor Deerfield's early settlers, the "Crackers" who had migrated from Georgia and North Florida, but to celebrate the end of the town's farming season. "Cracken" is the process of separating the kernels from the corn cob.

By the end of 1950, the city's population stood at around 2,000. In 1951, Deerfield Beach changed its name once again, this time to The City of Deerfield Beach. Five years later, the city adopted a city manager-commission form of government, and George Schaefer served as the town's first city manager. On March 22, 1957, the J.D. Butler Bridge, a four-lane bridge across the intracoastal, was opened.

In 1960, the town's population was around 9,500. In that decade, like most communities in South Florida, beach erosion was a big problem. To combat the problem, Deerfield developed an innovative way to control it. The plan they used was to set up a series of boulders or "rubble mounds" along the beach and then add a groin and post system. The idea was that after the waves break over the boulders, the groins capture the sand, which is then deposited on the beach instead of being swept back into the ocean. The results can be seen today as Deerfield has one of the best beaches in South Florida.

In October 1962, Deerfield Beach's pier was destroyed by Hurricane Ella. A month after that, a demolition team led by Deerfield resident Bill Keitt tore the remaining portion down. August 1963 saw a new $128,000, 720-foot long fishing pier built. It was opened in February 1967 and began to operate 24 hours a day. The city continued its growth through the 1960s and 1970. By

1972, the city's population stood around 20,000.

In February 1976, the nation's bicentennial year, President Gerald Ford visited Deerfield Beach. He stopped by the pier, talked to residents, and gave a speech. It was a big honor for the city. As the 1970s came to a close, the city had 17,130 residents. At the start of the 1980s, Deerfield Island Park was opened. Once called "Capone's Island," it had taken many years to complete and was finally opened to visitors to enjoy nature at its finest. Other construction projects were also begun or were completed in the decade. The Hilton Hotel, which was partially owned by Merv Griffin, opened in 1985. And in 1987, the last major beach hotel, the Embassy Suites, was completed and opened for business on the south end of the beach.

In 1986, the Sawgrass Expressway was opened, giving people a new western route to Fort Lauderdale and Miami. Because of that, people now had even more of an opportunity to live in Deerfield Beach because of the new, easier access to jobs in those parts of South Florida that were once considered too far away.

As the city moved into the 1990s, westward expansion continued. Hillsboro Boulevard was widened to six lanes, and apartments and homes continued to be built. In the meantime, new businesses have been brought to the city, and this year, 2000, Florida Atlantic University announced plans to bring the newest phase of its research and development park to Deerfield Beach. As the City of Deerfield Beach enters the new millennium, the population stands at 60,000 and still growing.

What was once a bare land of scrub and rock over 75 years ago is now a prospering community, with an active, proud population and a bright future ahead. In the pages that follow, you will be taken on a photographic journey through the history you have just read. You will see what the town looked like at its birth and you will see what it looks like at the start of the 21st century. You will see the faces and places that have made this city what it is today.

So sit back, relax, and begin turning the pages to learn about Deerfield Beach's history.

One
1890–1909

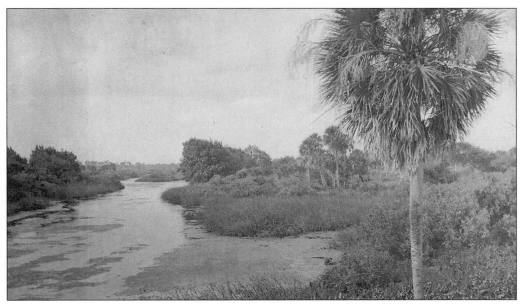

A Scenic View along the Hillsboro River. Life in Deerfield began along the shores of the Hillsboro River, where the fish were abundant. In those early days, the water was so clean and clear, you could drink it right from the river, according to Ardena Horne, one of the early pioneers of the town.

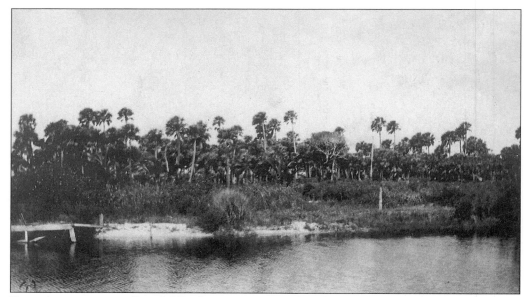

PINEAPPLE GROVES. Deerfield's first major agricultural crop was pineapples. Groves of pineapples could be found throughout Deerfield in the 1900s.

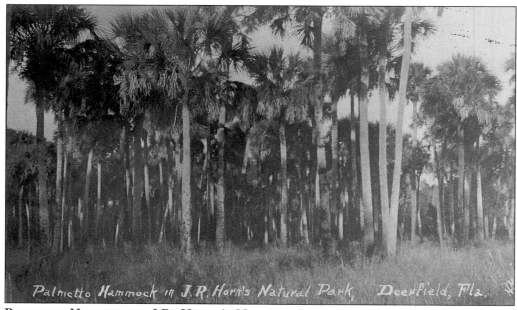

PALMETTO HAMMOCK IN J.R. HORNE'S NATURAL PARK. An early view shows a stand of palmetto trees that grew naturally throughout the area.

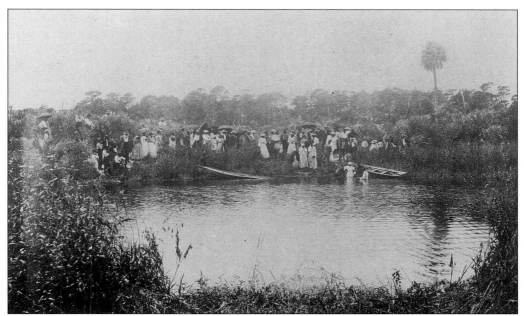

BAPTISM ON THE RIVER. In those early days, from 1900 through the 1930s, baptisms along the Hillsboro River were common.

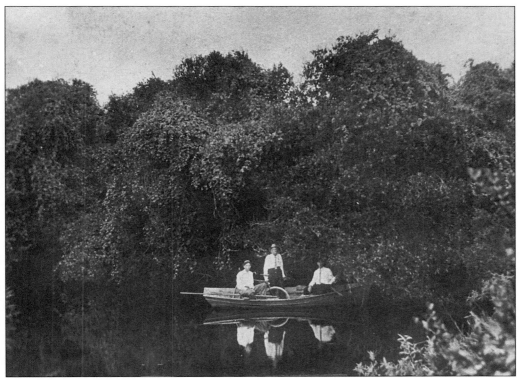

A PEACEFUL AFTERNOON OF BOATING ALONG THE HILLSBORO RIVER. Settlers would use the river for travel, fishing, commerce, and fun in the early 1900s.

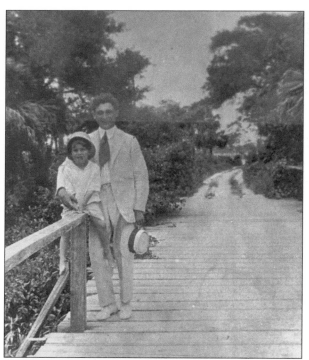

PORTRAIT ON A BRIDGE, 1905.
One of the town's early pioneers, Howard Bracken, stands on the first wooden bridge across the Hillsboro River. It connected Deerfield Beach with Boca Raton and was situated at what is now North River Drive.

THE ROBINSON HOUSE. Mr. and Mrs. M.A. Robinson arrived in 1908 and built this wooden house. In 1913, the First Baptist Church was organized by eight members in the living room of the Robinson's home. The house then became a center for neighborhood gatherings, as well as church meetings. An extra room was added because Mrs. Robinson sewed for other people, had a hat shop, and sold yarn goods and trimmings. The Robinsons lived in the house until the 1940s, when they sold it to Lottie Ewald, who lived there until 1975. The house was destroyed by fire in 1977.

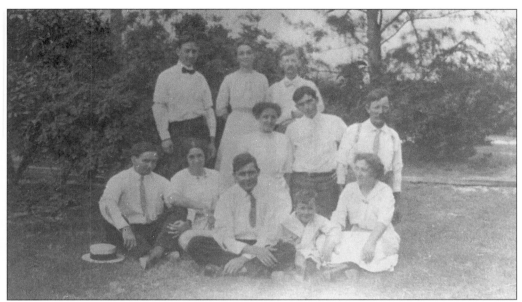

AN EARLY DEERFIELD FAMILY. In the early 1900s, only a few hundred settlers occupied Deerfield Beach. Here is an unidentified family from the early days of the town's development.

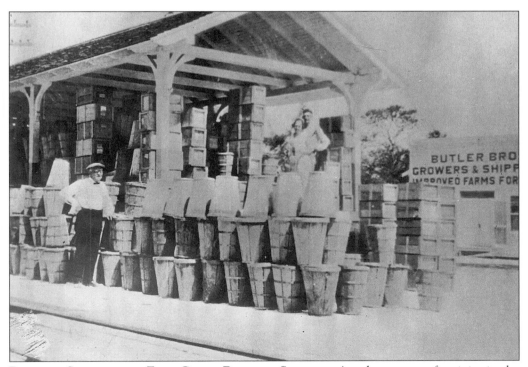

PRODUCE SHED AT THE EAST COAST RAILWAY STATION. Another center of activity in the early days of Deerfield was the East Coast Railway Station. The railroad was the major provider of transportation to the north and south in Florida at that time and was also the main method of shipping produce grown in the area.

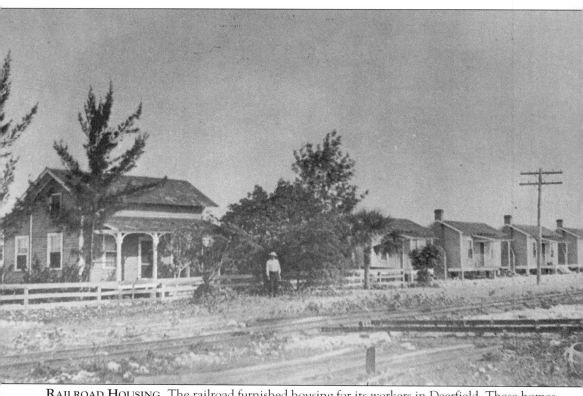

RAILROAD HOUSING. The railroad furnished housing for its workers in Deerfield. These homes stretched along Dixie and Hillsboro Boulevard. In this photo, Hezejah Munnings, a tenant who worked on the Florida East Coast Railroad in Deerfield, stands near the section houses where he lived.

Two
1910–1919

DEERFIELD, STILL A FARMING COMMUNITY. Pictured here is a road through a grapefruit grove on what is now the site of the Deerfield Beach Country Club. J.R. Horne was the caretaker of the grove. In 1920, he was killed in a dispute with the railroad workers, who had allegedly stolen some grapefruit.

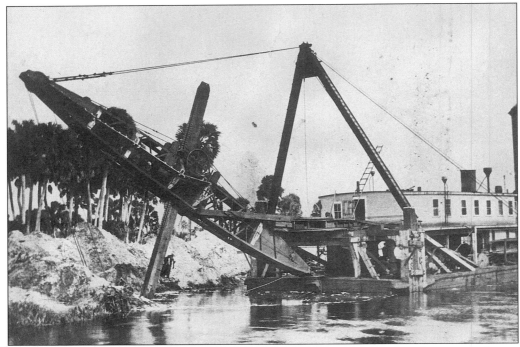

THE DREDGING OF THE HILLSBORO CANAL. The Hillsboro River was nothing more than a creek that turned into swampland northwest of the town. In 1911, dredging began. When completed, the Hillsboro Canal would link Deerfield Beach and Lake Okeechobee some 45 miles to the northwest and would become a major way of delivering produce and supplies throughout the area.

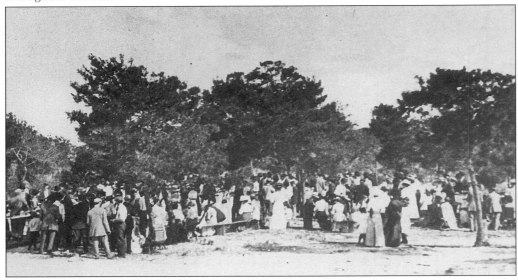

HILLSBORO-OKEECHOBEE CELEBRATION. On December 14, 1911, when the dredging of the Hillsboro Canal began, a groundbreaking celebration was held and Florida governor Albert Gilchrist and the state cabinet attended. Engineer ? Wright can be seen in the photo giving a speech.

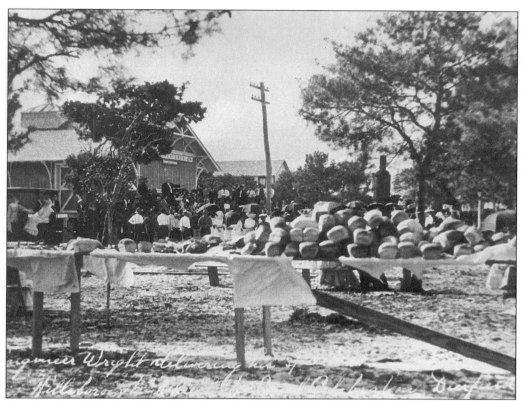

HILLSBORO-OKEECHOBEE CELEBRATION. Townspeople enjoy the festivities at the groundbreaking ceremony for the Hillsboro Canal.

A REVIVAL GATHERING. A group of townspeople gather for a revival in Deerfield near Dixie Highway and what is now the downtown area.

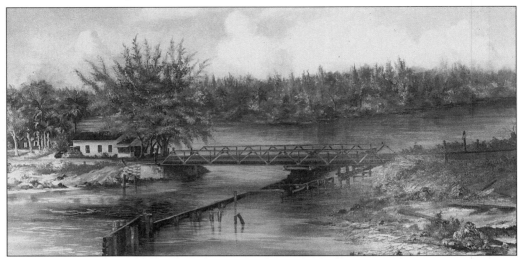

OLD BRIDGE OVER THE HILLSBORO RIVER. This rendering depicts the old bridge that crossed the Hillsboro River. Built in 1917, the bridge was a revolving structure with a wooden floor that could be opened by a hand crank. The bridge tender at that time was named Payette; he was followed by the Roosevelt family, then the Jones family. The road crossed the Hillsboro River, then turned to the northeast and ended up where the present-day pier is located. The bridge was damaged by a barge in the mid-1950s.

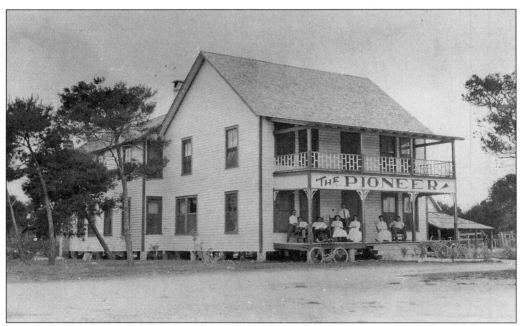

THE PIONEER HOTEL. The Pioneer Hotel was located just north of the intersection of Hillsboro Boulevard and Dixie Highway. It had its own water supply, which came from a tank located on the right side of the building. The hotel was severely damaged in the 1928 hurricane and was never used again.

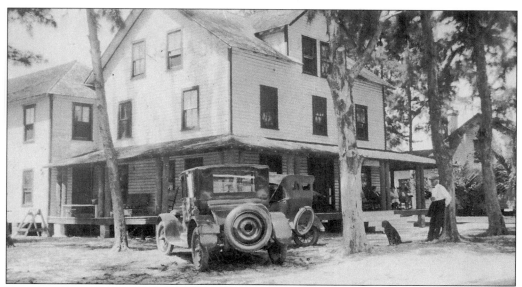

THE AUSTRALIAN HOTEL. The other hotel in town was the Australian Hotel, located south of the intersection of Hillsboro Boulevard and Dixie Highway. The proprietors, Mr. and Mrs. E.A. Thomas, were relatives of J.D. and Alice Butler. The hotel suffered damage in the hurricane of 1926 and then burned down on September 29, 1927, when a kerosene water heater in the kitchen malfunctioned.

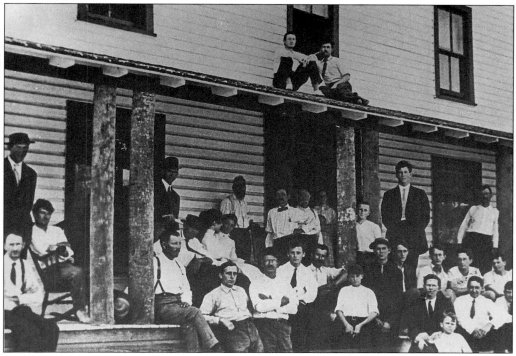

GATHERING AT THE AUSTRALIAN. A group of residents and friends gather on the front porch of the Australian Hotel.

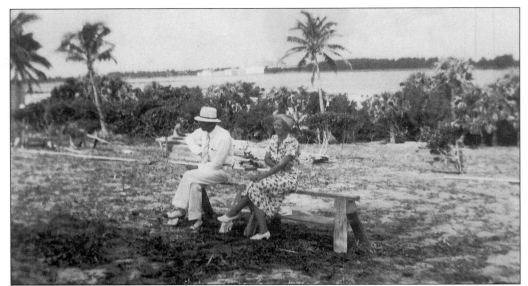

EARLY PIONEER J.D. BUTLER AND HIS WIFE, ALICE. J.D. and Alice Butler arrived in Deerfield Beach in 1910 to visit his aunt and uncle, Mr. and Mrs. E.A. Thomas, who were the proprietors of the Australian Hotel. The Butlers decided to stay, and according to J.D. Butler, it was a bold decision. "We found an open place where we could burn off the grass, put in a crop, and there we stayed."

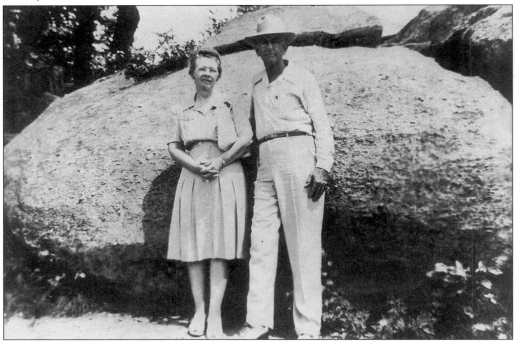

GEORGE EMORY AND MARJORIE BUTLER. In 1915, J.D. Butler wrote to his brother George Emory Butler Jr. back in Carthage, Texas, and suggested he move to Deerfield and join him. George and his wife, Marjorie, came out to Deerfield and stayed. He was an active pioneer and became the town's first mayor in 1925.

Three
1920–1929

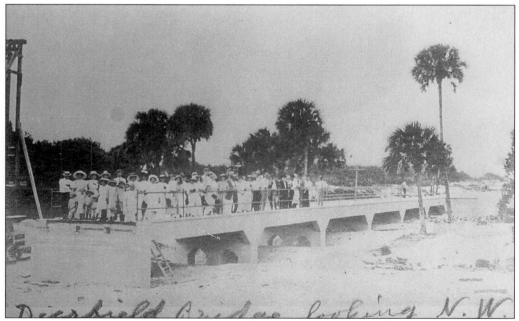

THE OLD BRIDGE ACROSS THE HILLSBORO RIVER. A group of people stand on the Old Bridge that crossed the Hillsboro River on Dixie Highway.

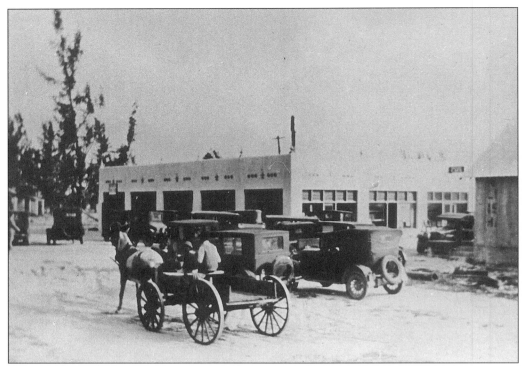

THE KESTER BUILDING. The Kester Building was used as a commercial hub in the center of town. It was later damaged in the 1928 hurricane and then rebuilt.

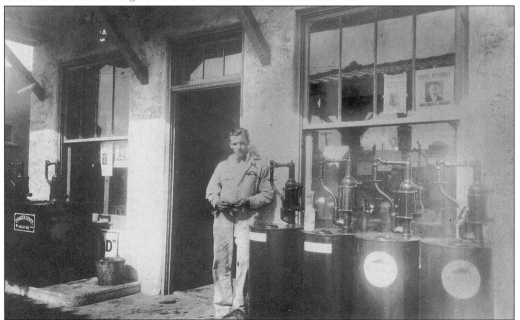

OLD-TIME SERVICE STATION. The Newell Johnson Service Station, owned by the Thomas brothers, Ralph and Jaimie, used to sit at the corner of Old Dixie Highway and Hillsboro Boulevard.

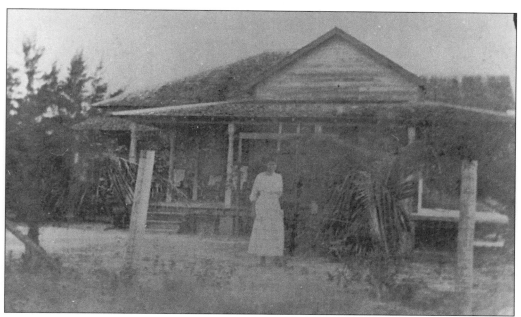

A C.B. Scott House. Pictured here is one of Charlie B. Scott's houses, possibly one located in western Deerfield. The woman in the photo may be Scott's wife.

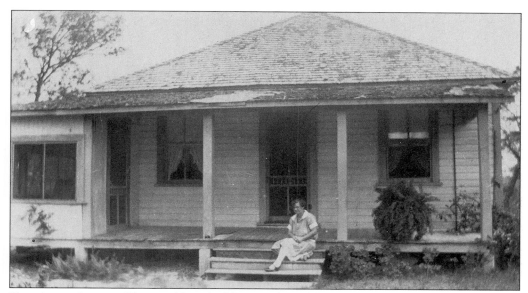

The Alice Ambler House. Alice Ambler, another of the early pioneers in Deerfield, relaxes on the front porch of her home.

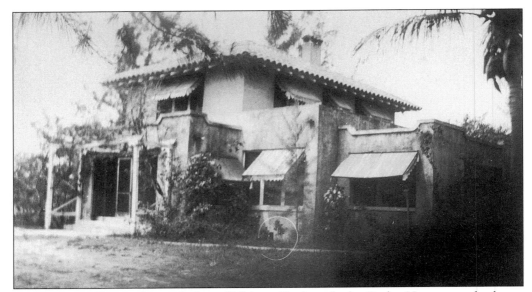

THE BUTLER HOUSE. Located along Hillsboro Boulevard, the Butler House was the home of early settlers J.D. and Alice Butler. The Butlers originally lived across the street. This home was built on the site where it stands today after the original home was destroyed by the 1928 hurricane.

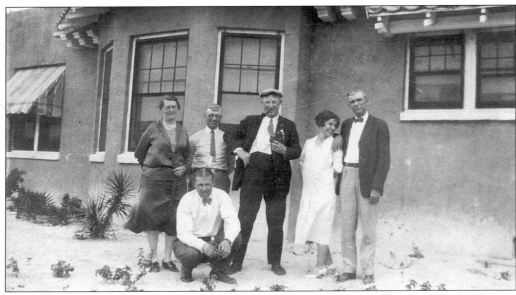

A GATHERING AT THE BUTLER HOUSE. A group of people pose together at the Butler House.

J.D. (LEFT), ALICE, AND GEORGE EMORY BUTLER. George Emory is shown here in leggings, which were usually worn as protection against snakes.

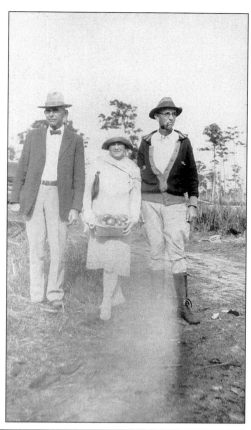

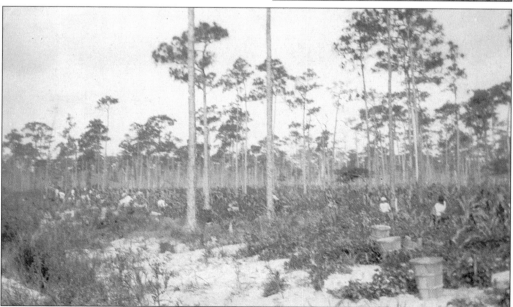

WORKING ON THE FARM. Farm workers are seen picking beans on the Butler Farms in the late 1920s. (Courtesy of Jack Butler.)

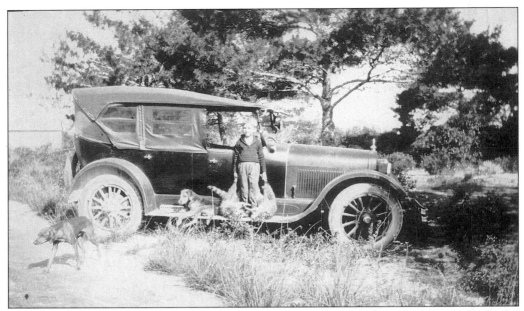

A-HUNTING WE WILL GO. Hunting was a popular diversion in the early days on the Butler Farms. In this photo, Jack Butler proudly holds two raccoons while standing by a 1925 Buick. (Courtesy of Jack Butler.)

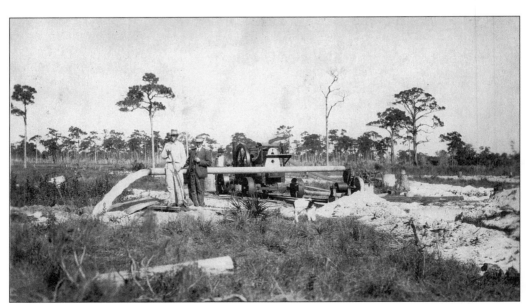

IRRIGATION PUMP ON BUTLER FARMS. One of the first irrigation pumps in Deerfield was at the Butler Farms. The one shown in this photograph was located at what is now Deer Creek. George Emory is shown standing near the pump on the left, holding the shovel. (Courtesy of Jack Butler.)

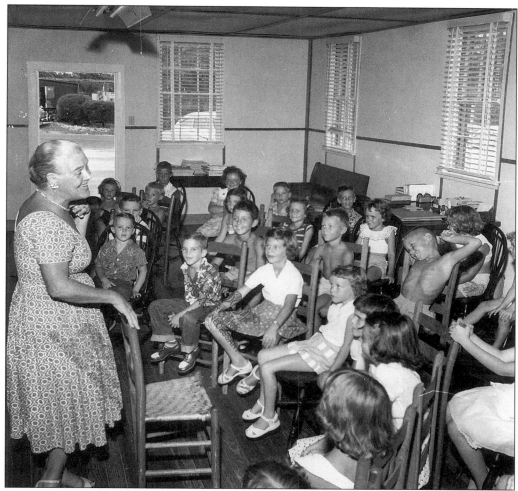

STORYTELLING HOUR AT THE DEERFIELD WOMEN'S CLUB. Francis Barts holds a storytelling session with local children at the Deerfield Women's Club on the corner of Federal Highway and Hillsboro Boulevard. It was in 1919, the year that women fought and won the right to vote, that the Deerfield Women's Club was organized. Mrs. George Carlton was named president. There were 21 members who paid 10¢ a month in dues. The organizational meeting was held at the Australian Hotel.

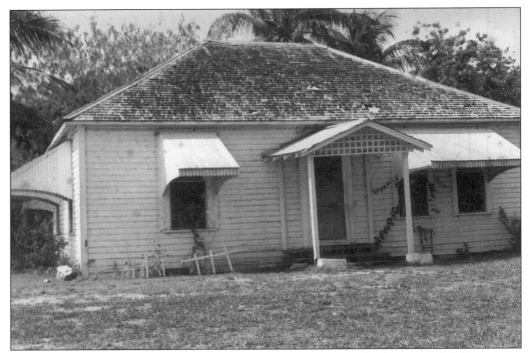

THE GEORGE CARLTON HOUSE. George Carlton was an early farmer and fisherman in Deerfield, though he later moved to the Ft. Pierce area. His house, seen in this photo, stood on the site of Deerfield's current post office.

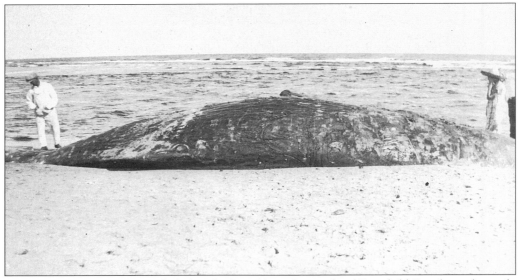

UNEXPECTED VISITOR. A whale beached itself on the sands of Deerfield Beach in the early 1920s. It became an attraction, and people came to see it from far and wide. (Courtesy of Leona Meeks Arnau.)

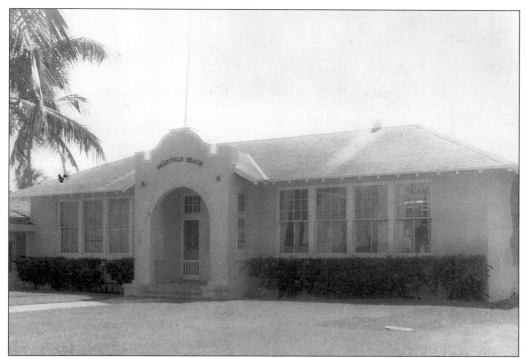

THE 1920 SCHOOLHOUSE. The 1920 schoolhouse was originally a two-room building, holding grades one through eight.

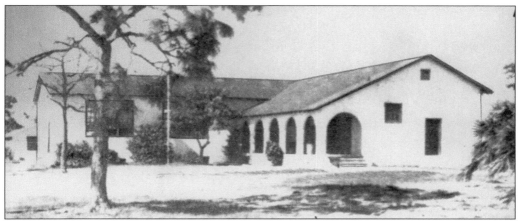

THE BRAITHWAITE SCHOOL. Built in 1929, it was the second African-American school in Deerfield Beach.

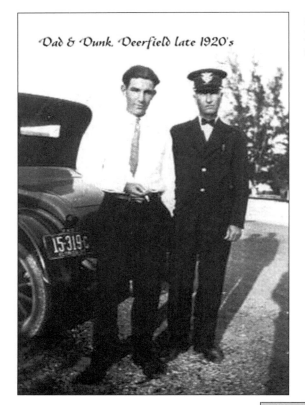

Dad & Dunk. Deerfield late 1920's

CHIEF OF POLICE W.D. MACDOUGALD. Pictured here are Julian A. Arnau (left) and Chief of Police W.D. MacDougald. (Courtesy of Leona Meeks Arnau.)

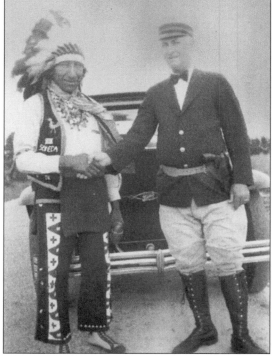

A VISITOR TO DEERFIELD. Chief MacDougald greets a Seminole Indian chief, part of a group of Native Americans visiting Deerfield. Some of the Seminoles stayed on MacDougald's porch during their visit. (Courtesy of Leona Meeks Arnau.)

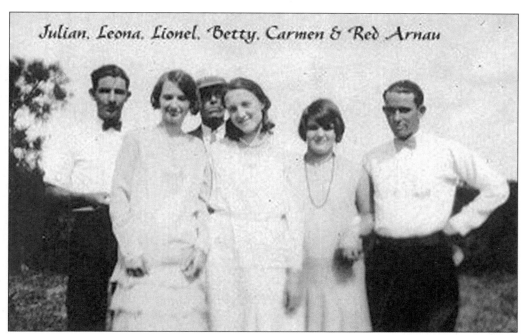

Julian, Leona, Lionel, Betty, Carmen & Red Arnau

THE ARNAU FAMILY. This photograph, taken around 1928, includes, from left to right, Julian, Leona, Lionel, Betty, Carmen and "Red" Arnau. (Courtesy of Leona Meeks Arnau.)

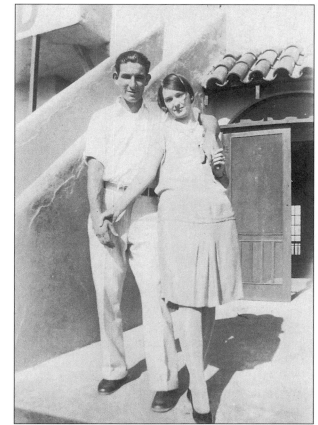

JULIAN AND LEONA MEEKS ARNAU. This photo of the couple was taken in front of the casino that used to be on Deerfield's oceanfront in the late 1920s. The building was completely washed away during a hurricane in the late 1940s. (Courtesy of Leona Meeks Arnau.)

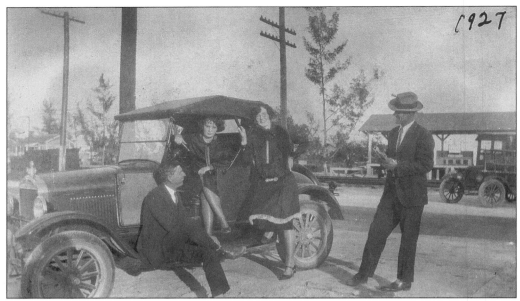

A DAY'S OUTING. Leona Meeks Arnau (sitting in car) and Billie Meeks (standing) enjoy a day out with some friends. The two men are unidentified. (Courtesy of Leona Meeks Arnau.)

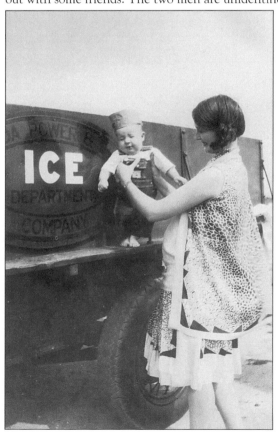

DADDY'S ICE TRUCK. Leona Meeks Arnau and her son Jack are pictured by the Florida Power and Light ice truck operated by her husband, Julian Arnau. (Courtesy of Leona Meeks Arnau.)

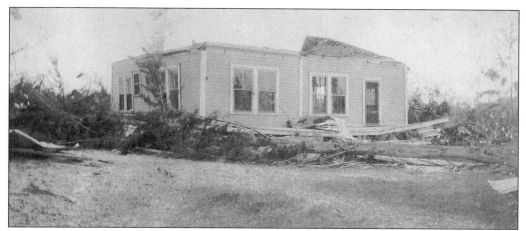

THE 1928 HURRICANE. In 1926, a hurricane hit Deerfield, causing a great amount of damage. Two years later, while the city was still recovering from that storm, the 1928 hurricane hit, destroying most of the town. Because of the hurricanes, and the depression that would hit in 1929, it would take years for the city to recover. This photo shows the damage sustained by the home of J.R. and Ardena Horne. (Courtesy of Leona Meeks Arnau.)

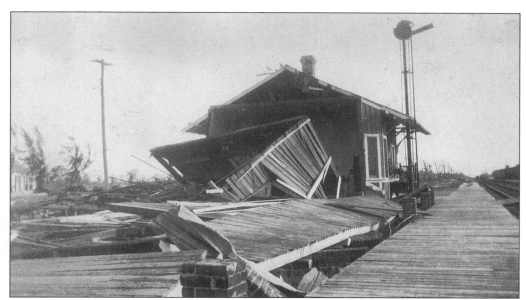

FLORIDA EAST COAST (F.E.C.) RAILROAD DEPOT. This photo shows the 1928 hurricane damage to the F.E.C. Railroad Depot. (Courtesy of Leona Meeks Arnau.)

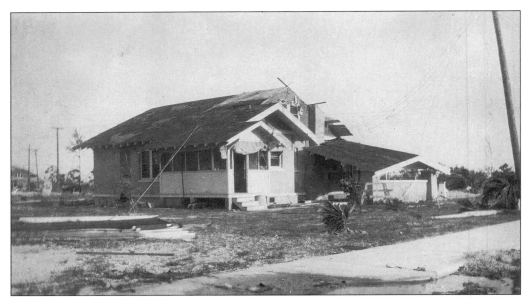

AGENT L. WALDRON'S HOME. This photograph depicts the 1928 hurricane damage to the home of F.E.C. Railway agent L. Waldron. (Courtesy of Leona Meeks Arnau.)

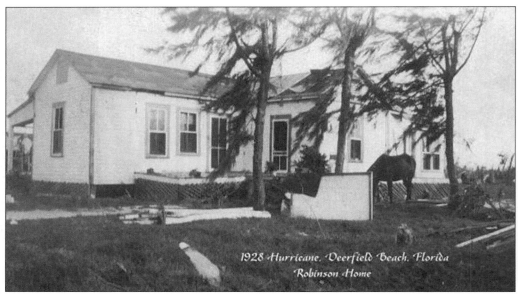

1928 Hurricane. Deerfield Beach, Florida
Robinson Home

THE ROBINSON HOUSE, 1928 HURRICANE DAMAGE. (Courtesy of Leona Meeks Arnau.)

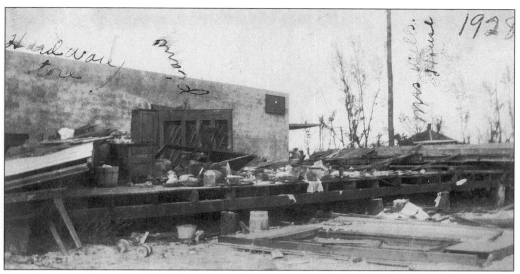

MacDougald House, 1928 Hurricane Damage. (Courtesy of Leona Meeks Arnau.)

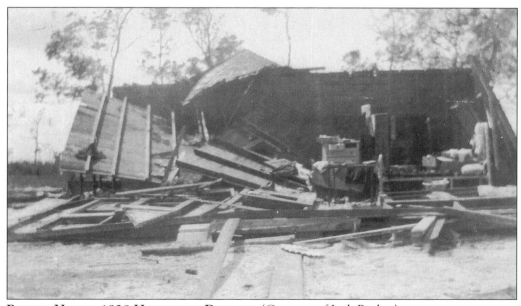

Butler House, 1928 Hurricane Damage. (Courtesy of Jack Butler.)

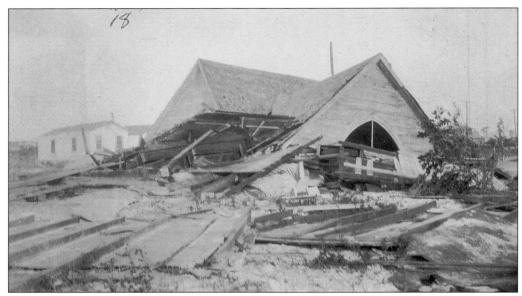

1928 Hurricane Damage to the First Baptist Church. (Courtesy of Leona Meeks Arnau.)

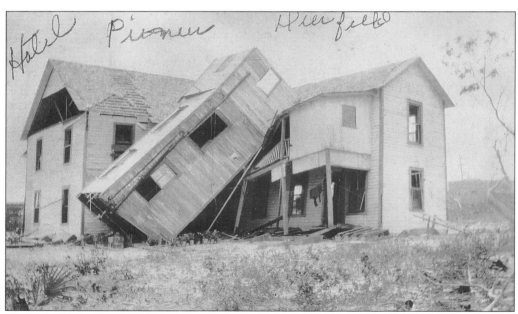

Pioneer Hotel, 1928 Hurricane Damage. The hotel was never used again following the devastating storm. (Courtesy of Leona Meeks Arnau.)

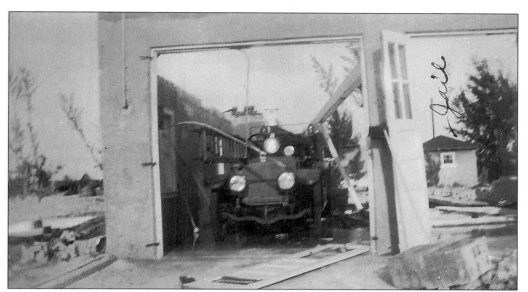

FIRE HOUSE, 1928 HURRICANE DAMAGE. (Courtesy of Leona Meeks Arnau.)

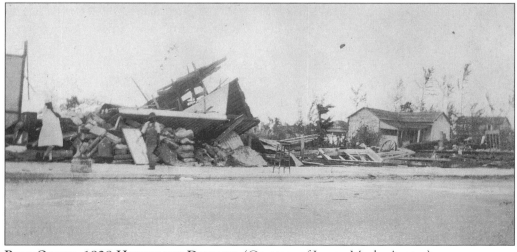

POST OFFICE, 1928 HURRICANE DAMAGE. (Courtesy of Leona Meeks Arnau.)

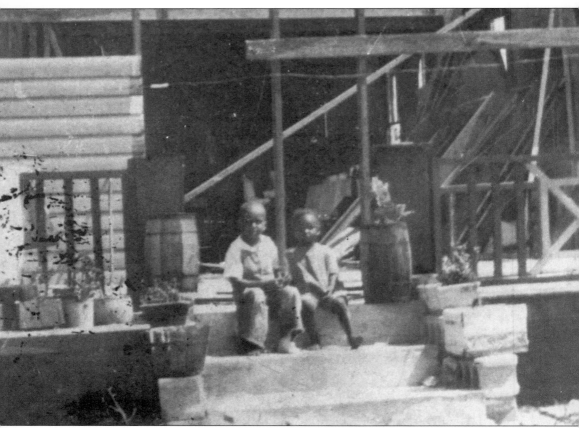

THE DAY AFTER THE HURRICANE. The construction of W.S. and Margaret Fullins's home was finished in August of 1928, and in September 1928, the hurricane hit town. Here the couple's children sit on what remained of their front porch the day after the hurricane. The front porch and the front of the house were blown away. All that remained were the kitchen and the back rooms. Mr. and Mrs. Fullins rebuilt their home and lived there for many years.

Four

1940–1949

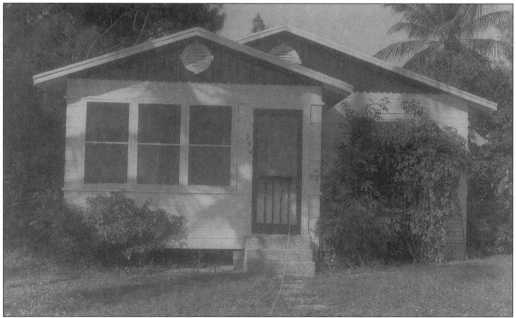

THE KESTER COTTAGE. Built of Dade pine by William Kester in the 1930s, the Kester Cottages were small, low-cost, one-, two-, and three-bedroom houses built during the Depression era, providing homes for many families to rent. This house was restored by the Deerfield Beach Historical Society and now sits behind the Butler House. Note the cut-outs in the shutter, which were a trademark of the Kester Cottages.

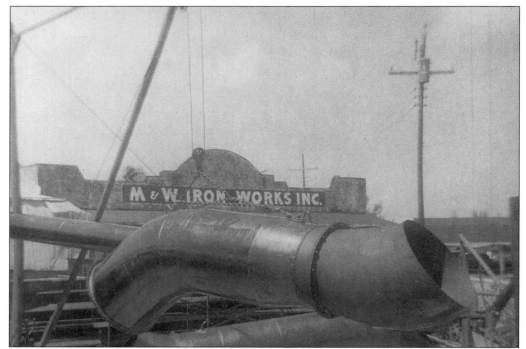

M&W Iron Works, Inc. An early photograph shows the M&W Iron Works company founded by J. Marlin Eller in 1925. Today the company is called Moving Water Industries, and it builds pumps and machines around the world.

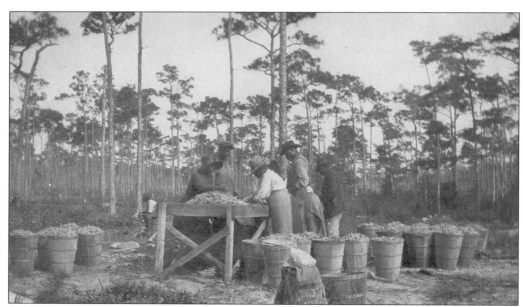

Grading Beans. Farm workers grade beans on the Butler Farm in the 1930s.

THE VALDAMA HOWARD RESIDENCE. Pictured here is a typical 1930s home in Deerfield.

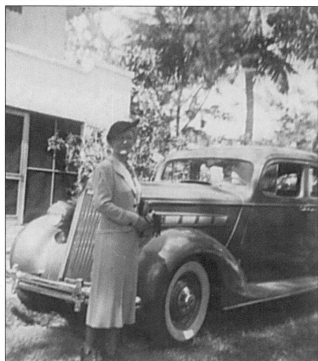

ALICE BUTLER. Alice Butler is seen standing next to the Butler family's 1936 Packard.

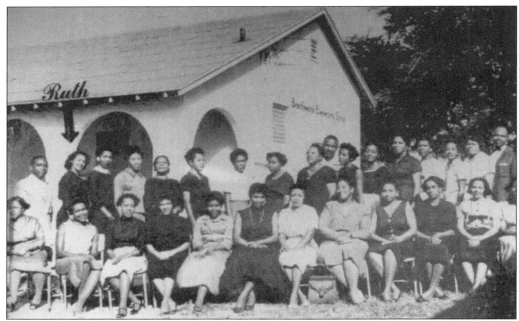

TEACHERS OF THE PAST, C. 1950. Pictured here are the Braithwaite Elementary and Junior High School staff members. Vera Knowles Cox remembers the second-grade classroom, which had "two blackboards, a cloak room, nice seats, and varnished floors. On the walls were pictures to remind students about hygiene—pictures of toothbrushes, soap, and combs."

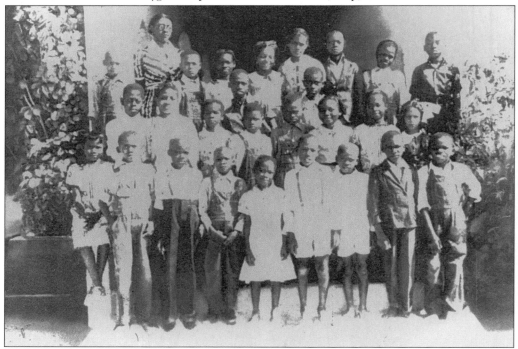

BRAITHWAITE SCHOOL CLASS. Mrs. Viola Johnson's second-grade class is pictured at the Braithwaite School in 1936.

Five

1940–1949

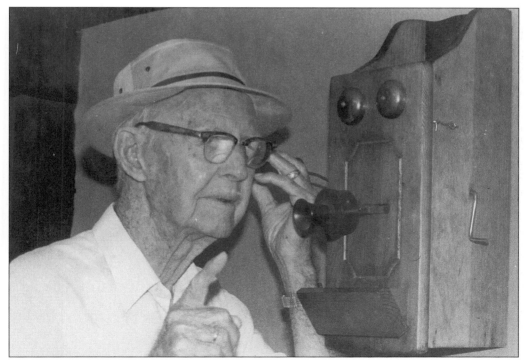

J.B. WILES. Two-time Broward County Commissioner J.B. Wiles is seen talking on one of Deerfield's early telephones. Wiles was a prosperous farmer and an avid fisherman in Deerfield.

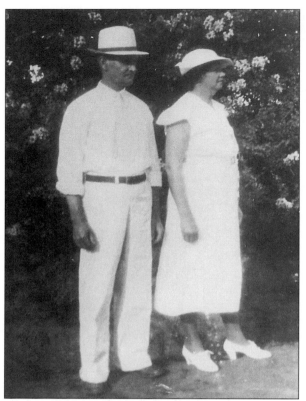

LEMUEL AND ETTA HORTON, THE MATERNAL GRANDPARENTS OF DAVID ELLER. This photograph was taken in 1947, shortly after the couple moved to Deerfield Beach. Horton had been a cotton farmer but worked in construction after moving to Florida.

MARLIN ELLER. Marlin Eller, the owner of M&W Iron Works, is shown in front of his company in the late 1940s.

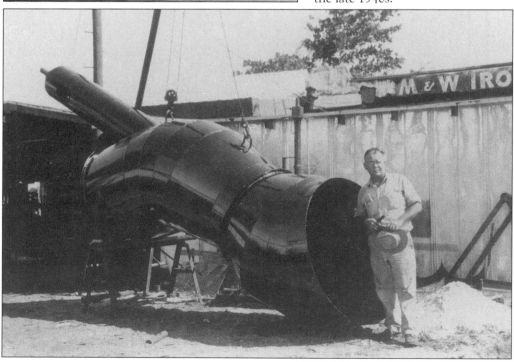

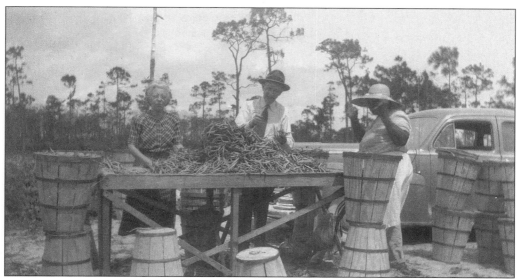

PICKING BEANS. Alice Butler (left) is seen on the family farm helping the bean workers.

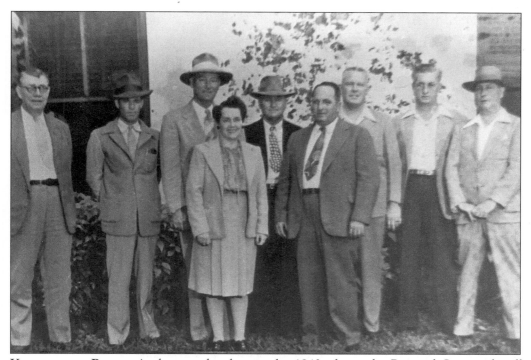

KEEPING THE PEACE. A photograph taken in the 1940s shows the Broward County sheriff officers and workers. Pictured, from left to right, are A.D. Marshall, Earl Sharp, Roy May, Sara Freeman, Virgil Wright, Sheriff W.R. Clark, A.M. Wittcamp, Robert L. Clark, and Harry Crooks.

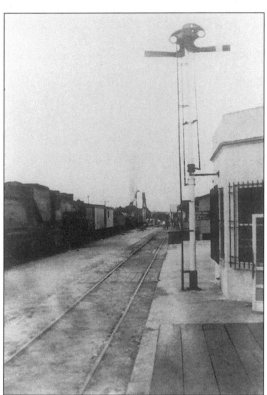

ARRIVING TRAIN. A train arrives at the Seaboard Airline Railroad Station in 1944.

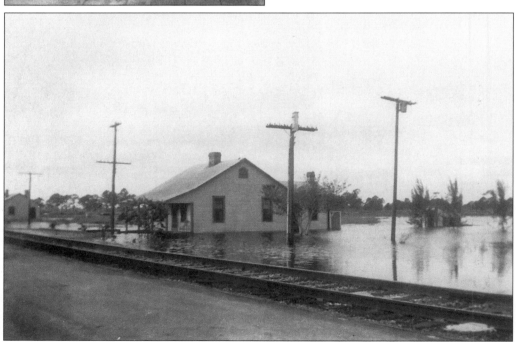

THE AFTERMATH OF A HURRICANE. This section housing to the west of the Seaboard Railroad Station is pictured after a hurricane around 1947.

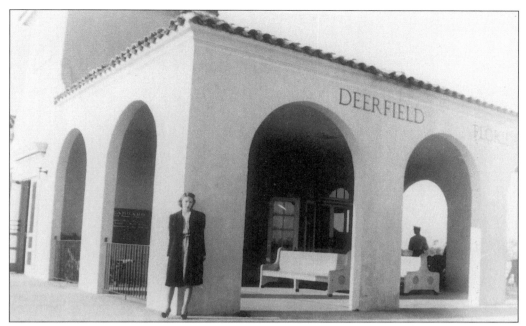

DEERFIELD TRAIN STATION, C. 1944. This photograph of the Seaboard Railroad Station shows the north side of the station and the open screen door on the east side.

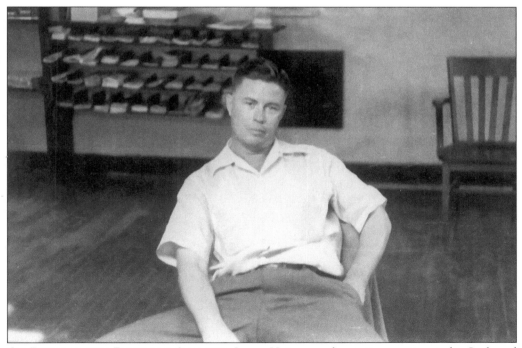

ON DUTY AT THE RAILROAD STATION. James Haire was the station master at the Seaboard Airline Railroad Station from 1944 to 1975. This photograph was taken around 1944.

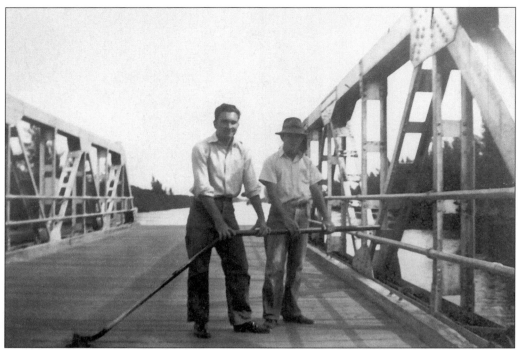

ON THE BRIDGE. Two unidentified people stand on the bridge crossing the intracoastal in 1941.

THE MCELWEE BUILDING. Seen here in the 1940s, it was built by Odas Tanner for $50,000 and would later be used as a city hall.

CELEBRATION DAY. The Lions Club of Deerfield Beach celebrates the opening of their new city park on Thursday, May 13, 1948, with a barbecue supper. Looking as though they are really enjoying the ribs are County Commissioner J.B. Wiles Jr. (left) and Mayor B.E. Chalker, the retiring president of the Lions Club. (Courtesy of Jack Butler.)

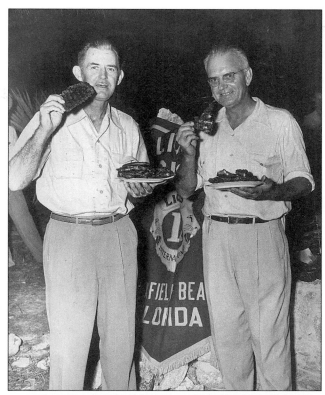

THE 1948–1949 LIONS CLUB SOFTBALL TEAM. The team consisted of many of the city's prominent leaders. From left to right are (bottom row) Willy Dame, Alan Ballard, Red Arnau, Bob Phlegal, Jack Butler, and unidentified; (top row) M.A. Peterson, Bob Butler, Milton Vincent, Jay Mosley, Barney Chalker, Hubert Morris, and Alvin Jones. (Courtesy of Jack Butler.)

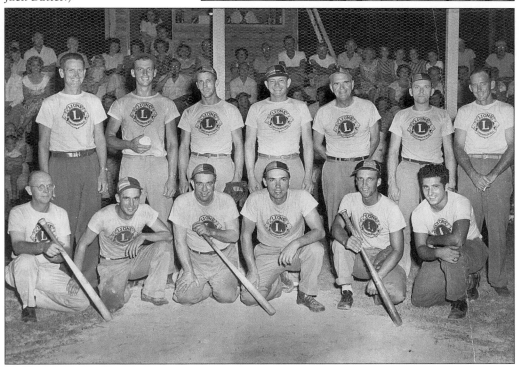

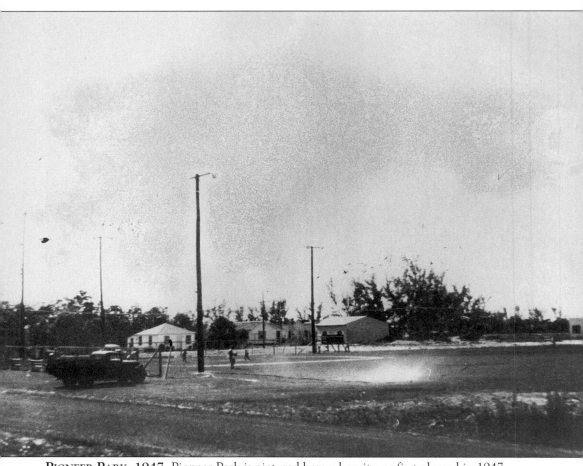

PIONEER PARK, 1947. Pioneer Park is pictured here when it was first cleared in 1947.

Six

1950–1959

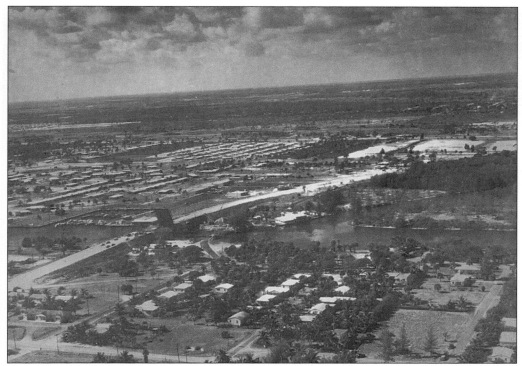

A Growing City. This aerial photo of Deerfield Beach, taken in 1963, shows what the area would develop into throughout the previous decade. Westward expansion had begun, but there was still a great deal of open land available.

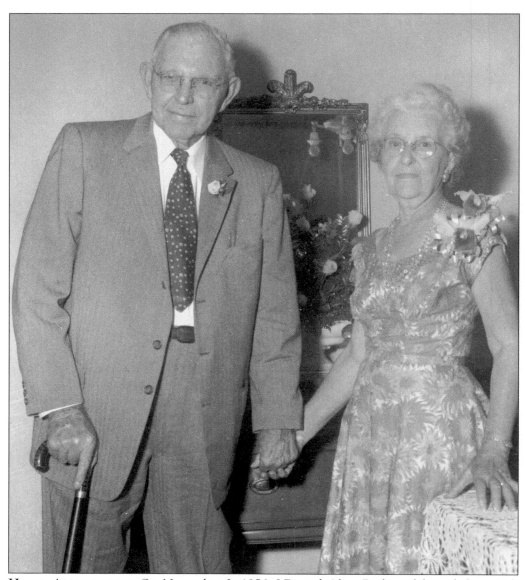

HAPPY ANNIVERSARY. On November 3, 1956, J.D. and Alice Butler celebrated their 50th anniversary. The story of their wedding was a romantic one, to say the least. J.D., who was born in Mitchell County, Georgia, and Alice, who was born in New Wilmington, Ohio, first met in the early 1900s in Texas. They came to Deerfield in 1910 for a visit and ended up staying. According to Alice, here's how the wedding took place. It "was Jimme's impatience to be wed that decided the locale of the ceremony," she said. "Rather than travel some distance to the county seat for a license and back again for an already planned church wedding, the prospective groom proposed a simpler solution. He just sent a message to the town clerk at the first railroad stop along the route they were traveling in Texas, told him the couple was coming through town on the train and to have a wedding license and a preacher waiting at the station. And that's the way it happened. The train conductor held the train, while the wedding ceremony took place in the observation car where he had previously lowered the blinds against the eyes of the curious bystanders who gathered at the station to watch."

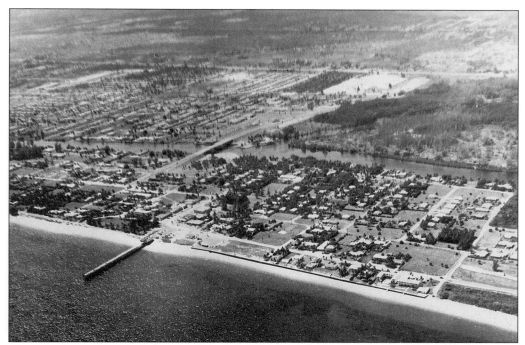

GROWING BEACHFRONT. An aerial photograph along the beach in Deerfield shows that it too is growing and expanding, just like the rest of the city.

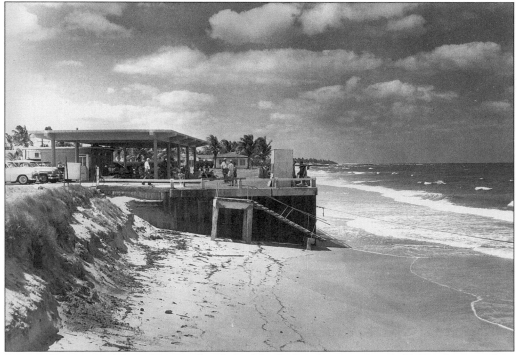

BEACH PAVILION. This photograph of the North Pavilion on Deerfield Beach was taken in 1955.

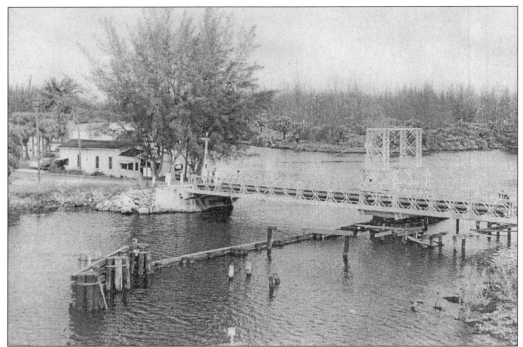

THE BAILEY BRIDGE. In the 1950s, the Bailey Bridge replaced the old wooden bridge over the intracoastal waterway, giving residents new access to the beach. The bridge was run by Grand Pa Jones and his son Bernie. Deerfield Island is visible in the background.

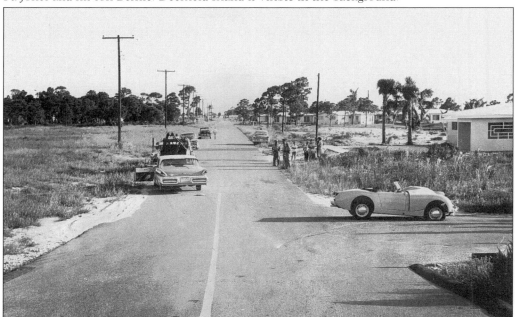

AUTO ACCIDENT. While an auto accident in 1959 is the central part of this photo, the scene also provides another glimpse into Deerfield's past. The photograph shows the 1200 block of Southeast Twelfth Avenue, looking south from the Hillsboro Bridge.

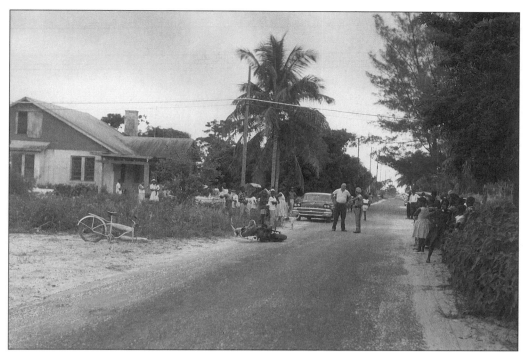

ANOTHER ACCIDENT. This one took place in 1959 on the 200 block of Southeast Second Avenue, looking south of Deerfield Builders Company. Former police chief Arthur Cole is seen standing in the street with his hands on his hips.

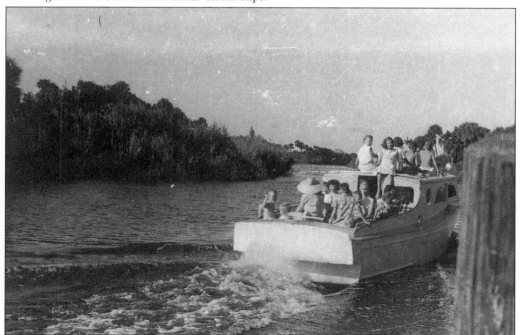

BOATING AFTERNOON IN 1959. A group of people enjoy a boat ride after leaving the Deerfield boat ramp in Pioneer Park.

HAPPY BIRTHDAY. This happy scene was captured at a birthday party for Susan Ballard in March of 1957. The house, which can be seen in the background, stood on Third Avenue, behind and south of city hall.

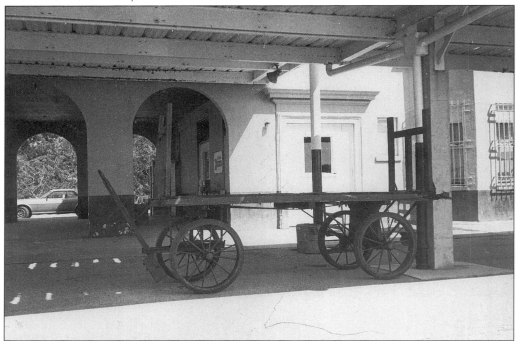

BAGGAGE CARRIER. An old-fashioned baggage carrier is pictured here at the Seaboard Airline Railroad Station.

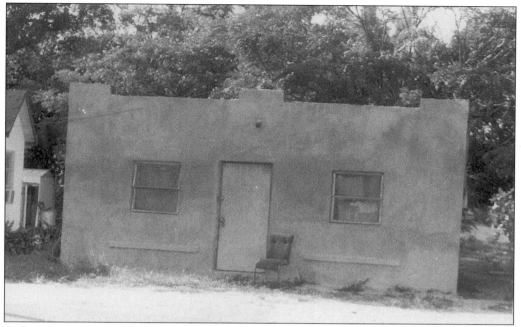

A BLOCK HOUSE. This is an example of an inexpensive type of house that was built in the 1950s.

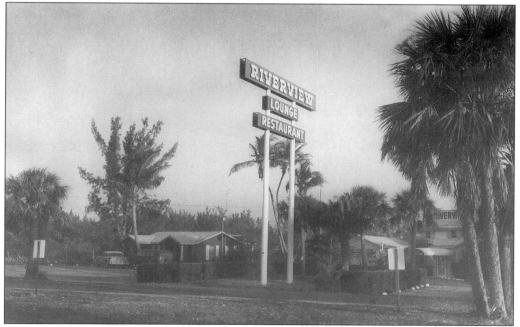

A DEERFIELD BEACH LANDMARK. The Riverview Restaurant and Lounge is seen here in the late 1950s. It originally opened in 1938, when Bill Stewart's uncle purchased a building in the eastern part of town that had once been used as a seafood and produce packing house. He remodeled it and, in 1938, opened it as a private gambling club with a clientele from the Boca Hotel and the Hillsboro Club.

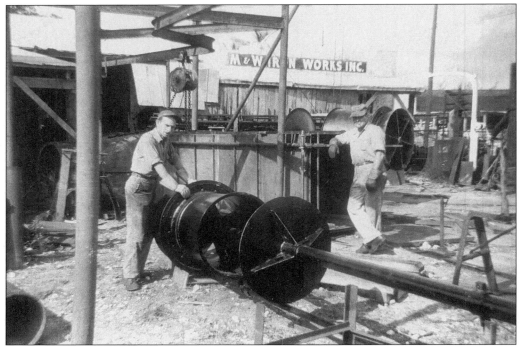

WORKING AT THE IRON WORKS. Workers Joe Page (left) and Horace Holloway relax during a work day in 1959 at the M&W Iron Works company.

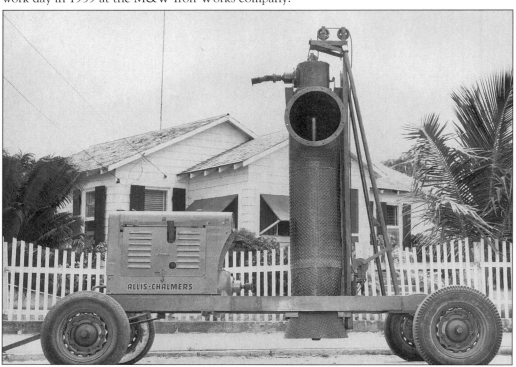

ELLER'S HOUSE. An M&W Pump is seen in front of Marlin Eller's house in the 1950s.

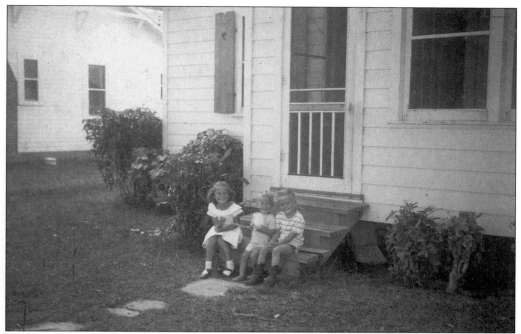

HANGING OUT AT A KESTER COTTAGE. Susan, John, and David Ballard sit on the porch of a Kester Cottage.

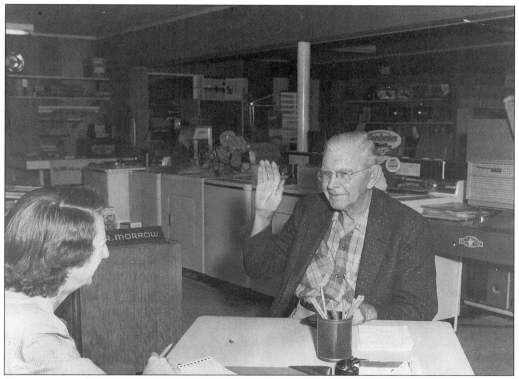

SWEARING-IN CEREMONY. Jessica Carter swears in J.D. Butler as a city commissioner in 1956.

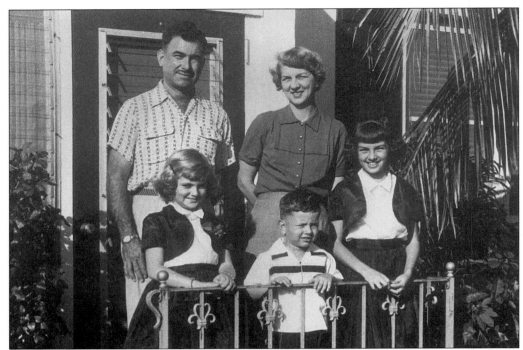

DIETRICH FAMILY PORTRAIT. A portrait of one of the city's leading civic families shows Edward P. Dietrich; his wife, Emily; and their children, from left to right, Christina, Edward H., and Joanna.

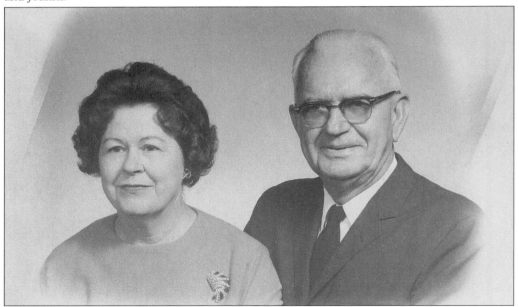

BARNEY CHALKER SR. AND MYRTLE CHALKER, 1955. Barney Chalker was a prominent civic leader in Deerfield Beach. He was mayor/municipal judge from 1942 to 1946, mayor/commissioner from 1956 to 1959, and a commissioner from 1956 to 1962. He died in November of 1976 at age 76.

G.E. BUTLER. A portrait of the first mayor of Deerfield shows George Emory Butler as he looked in the 1950s.

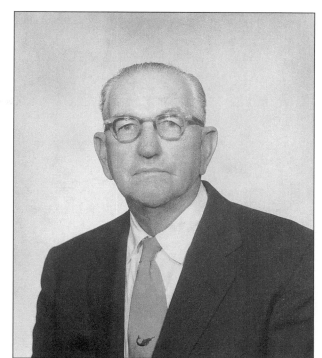

THE RIBBON-CUTTING CEREMONY OF BAILEY BRIDGE. J.D. Butler (left) and Barney Chalker (right) are seen here doing the honors at the ribbon-cutting ceremony of the Bailey Bridge.

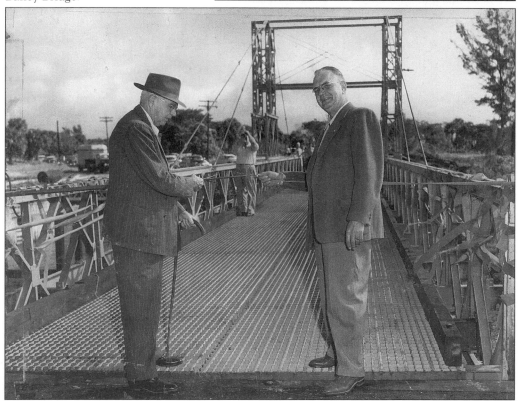

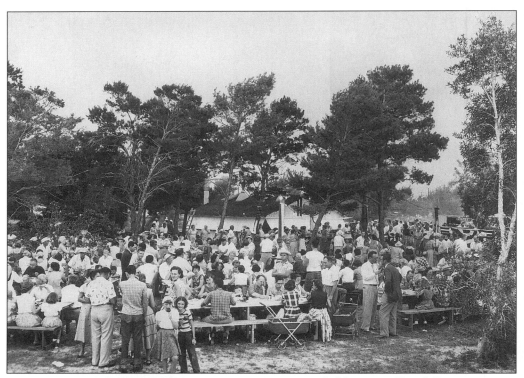

A "Cracker Day" Celebration. The residents of Deerfield Beach gather for one of the annual Lion's Club Cracker Day barbecues at Pioneer Park in the 1950s.

Granddad and Granddaughter. J.B. Wiles and his granddaughter Lisa Butler are seen in this photo from the 1950s. Wiles has a road named in his honor in western Deerfield Beach today. It is located where he once farmed.

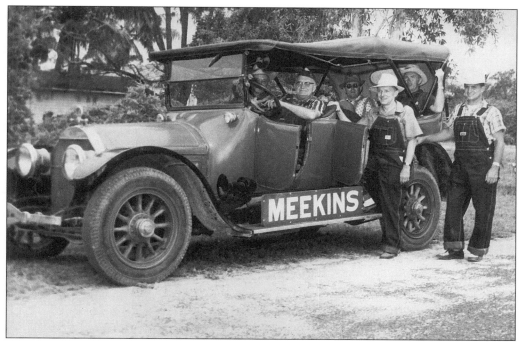

CRACKER DAY PARADE, LATE 1950S. Shown in this photograph are Barney Chalker (driving), Frank Lane (standing by the door), and Odas Tanner (in the back seat on the right).

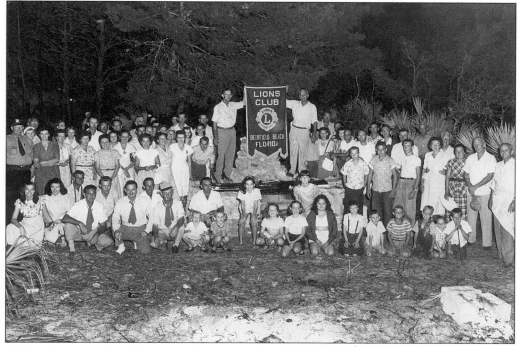

A FUN DAY FOR ALL. This group photo was taken after a fun day at the Lions Club barbecue. (Courtesy of Jack Butler.)

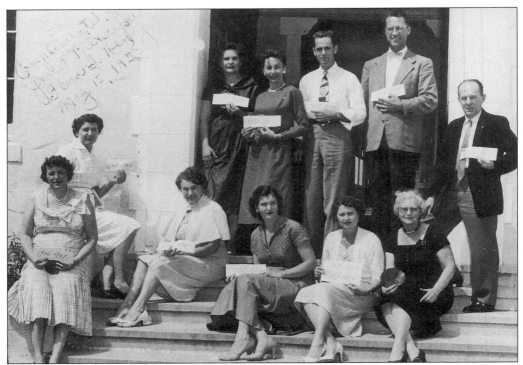

PTA PRESIDENTS. This photo of the Deerfield Beach Elementary School PTA presidents was taken in 1958. Included in this picture are (seated) Mrs. L. Jones (1946–1947), Mrs. Marlin Eller (1947–1948), Mrs. John Dickens (1948–1949); (standing) Mrs. Alvin Jones, Mrs. Jack Butler, Mr. Allen Bellard, and Rev. Arland Briggs.

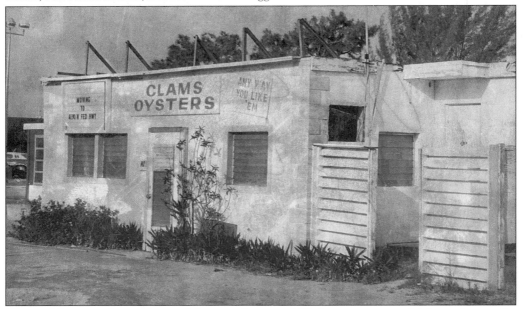

TARKS. This is a photo of one of the town's original Tarks restaurants, which are known for their clams and oysters.

Seven
1960–1969

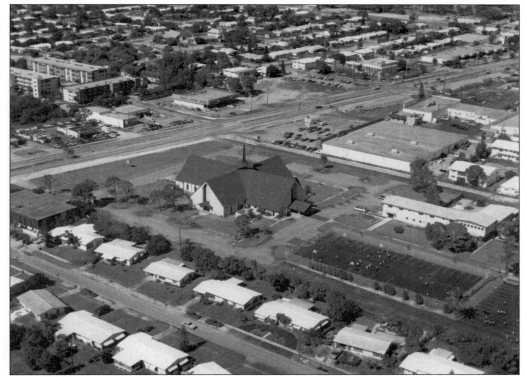

ST. AMBROSE. An aerial photograph shows St. Ambrose Church and School along U.S. 1 in Deerfield Beach.

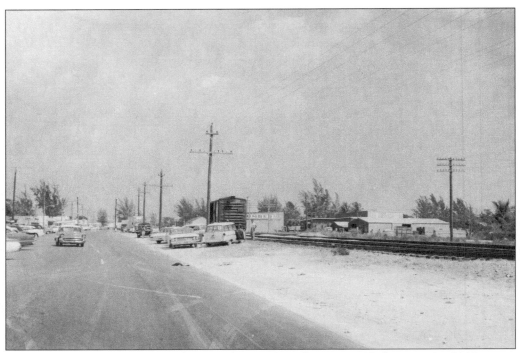

ALONG DIXIE HIGHWAY. This photograph was taken along Dixie Highway in the 1960s.

DRIVING THROUGH TOWN. This view of Deerfield Beach was taken at what would become the intersection of Hillsboro Beach Boulevard and Martin Luther King Boulevard.

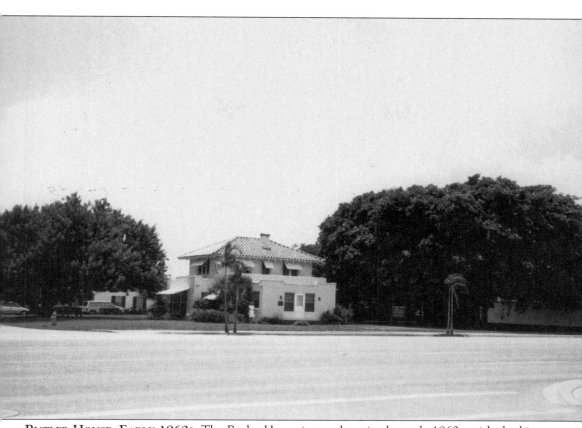

BUTLER HOUSE, EARLY 1960s. The Butler House is seen here in the early 1960s, with the big banyan tree behind the house.

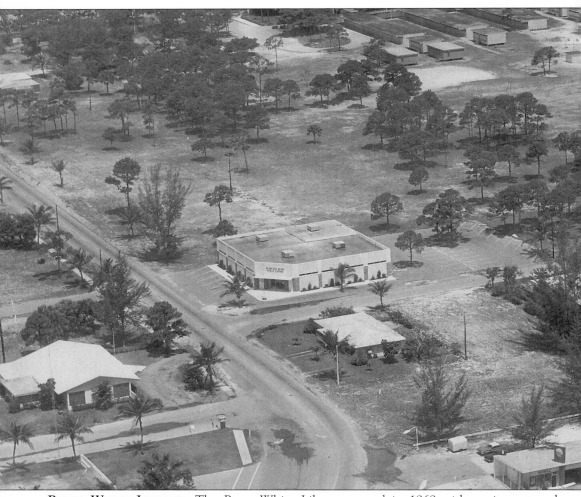

PERCY WHITE LIBRARY. The Percy White Library opened in 1969 with equipment and furnishings donated by the civic-minded citizens of the community for the use, benefit, and enjoyment of all the people in Deerfield Beach. It was all done under the guidance of the Deerfield Beach Library Association, Inc.

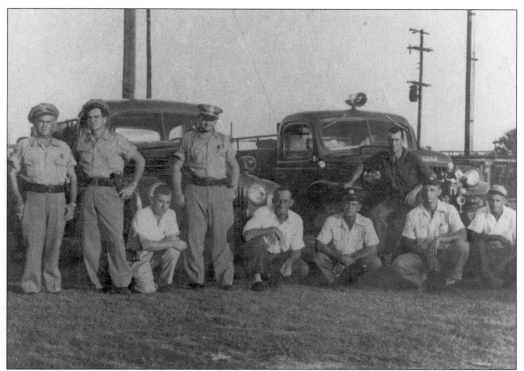

THE CITY'S FINEST. This photograph shows some of the police force of Deerfield Beach in the 1960s. Chief Andrew "Pappy" Brown is at the far left, Lloyd Newman is the fourth from the left, and Meryle Johnson is the sixth from the left.

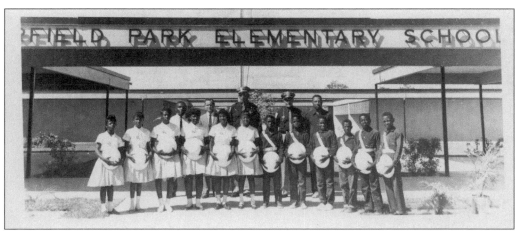

PHOTO DAY. A group of Deerfield Park Elementary School students stand with some visiting members of the Deerfield Beach police department.

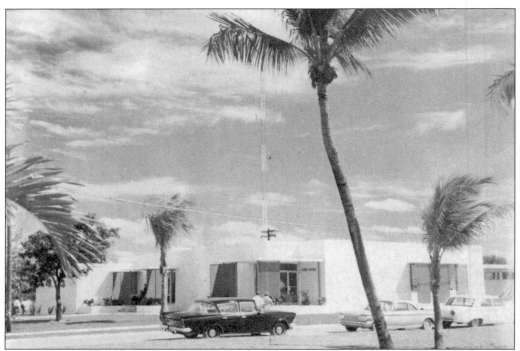

POLICE STATION, 1962. This station was located at 300 Northeast Second Street.

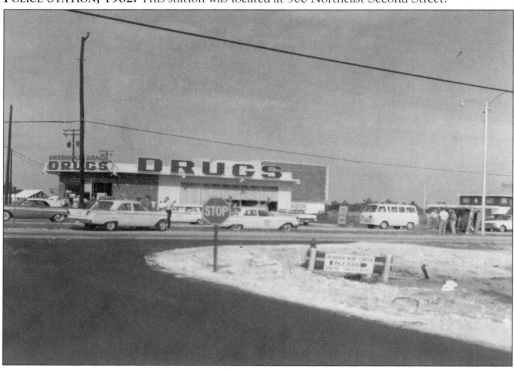

DEERFIELD IN THE 1960s. This view of Deerfield Beach shows the corner of U.S. 1 and Southeast Tenth Street.

DIXIE HIGHWAY IN THE 1960S. This photo shows the 200 block of South Dixie Highway, looking north.

THEN AND NOW. This photograph, taken in 1960, shows a scene near the Henry Machler Orchids on West Hillsboro Boulevard. Today the same location is near the entrance to Century Village on Hillsboro Boulevard.

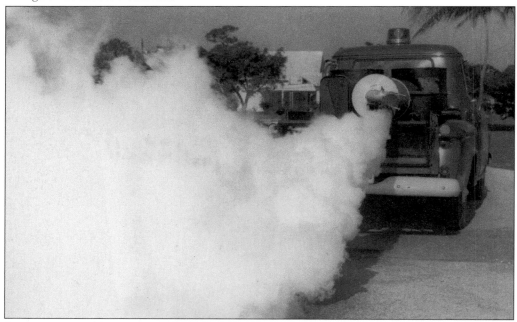

SPRAYING FOR MOSQUITOES. In the early 1960s, trucks would drive through town spraying DDT to control mosquitoes. This was quite a typical scene throughout cities and towns in South Florida at that time.

CITY HALL. The back of city hall and the west side of the police station appear in this view from 1960.

AN INFORMAL FAMILY PORTRAIT. Pictured here are J.D., grandniece Lisa, and Alice Butler.

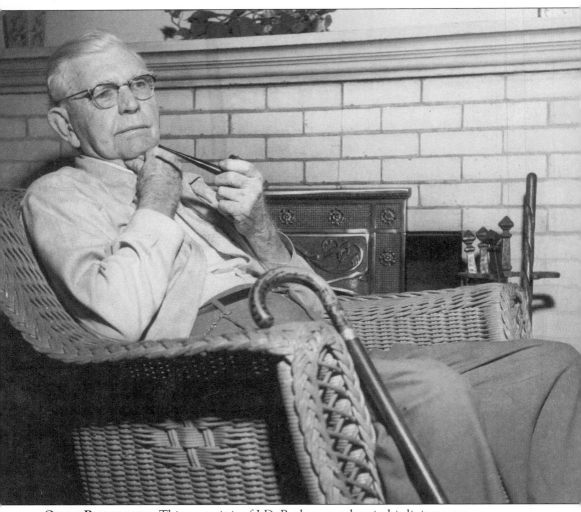

QUIET REFLECTION. This portrait is of J.D. Butler was taken in his living room.

JACK BUTLER. Jack was the son of G.E. Butler, Deerfield's first mayor.

A FAMILY GET-TOGETHER. A photograph of sisters-in-law Marjorie Ann Butler and Alice Butler shows the ladies standing in the garden behind the Butler House.

WORKING IN THE GARDEN. Alice Butler is pictured working in her beloved garden behind her home.

HANGING OUT AT THE BEACH. City Postmaster Ray Collier (far left) stands with some friends on Deerfield Beach near one of the first Tiki huts that was built. Standing next to Collier is Ed Boyle.

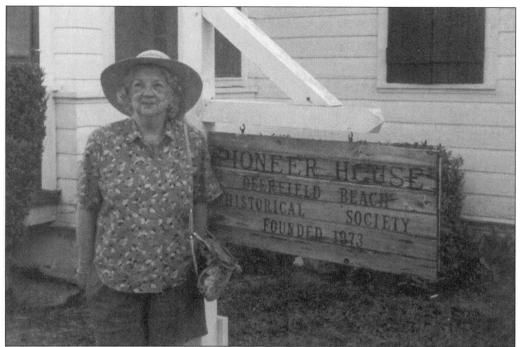

EMILY DIETRICH, 1960S.
Dietrich was Deerfield Beach's
first historian.

ED DIETRICH SR. One of the
city's civic and business
leaders, Dietrich started
Deerfield Builder's Supply.

A WALK IN THE WOODS. J.B. Wiles and his granddaughter Lisa Butler take a walk through the woods together.

SUE HORNE ARCHER. Archer was a descendant of Ardena Horne, one of the original pioneers of Deerfield Beach. When Ardena Horne first moved to Deerfield in 1903, the city was part of Dade County. In 1909, Palm Beach County was created and Deerfield became part of the new county. Then in 1915, Broward County was created and they became part of that new county. Ardena Horne said "we lived in three different counties without moving from our house."

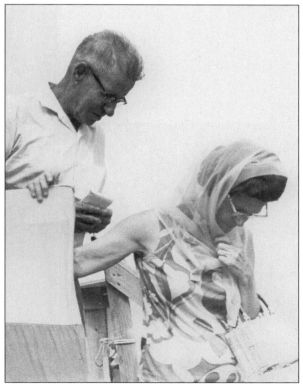

MR. AND MRS. JOHNSON. This photograph of Mr. and Mrs. Johnson was taken in the 1960s. She was a native to Deerfield Beach and had attended 24 annual Cracker Day celebrations.

DAVID ELLER. Eller was the son of the founder of M&W Pump Company. As a youngster, David and his friends would build a raft and go on adventures up and down the Hillsboro Canal.

J. ELDON MARRIOTT. A civic leader in Deerfield Beach history, Marriott took the top administrative office of city manager on June 15, 1960. He would serve until his resignation in 1967.

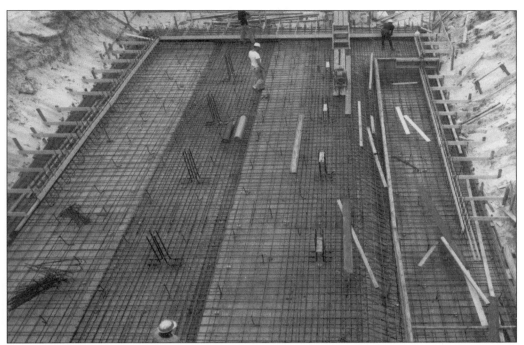

WATER IMPROVEMENTS. This photograph of the clearwell foundations at the Deerfield Beach Water Improvements was taken in July 1965.

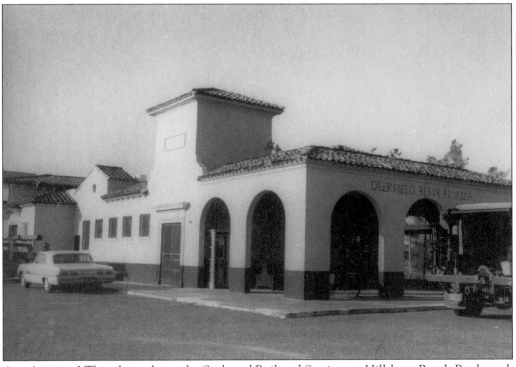

ALL ABOARD! This photo shows the Seaboard Railroad Station on Hillsboro Beach Boulevard.

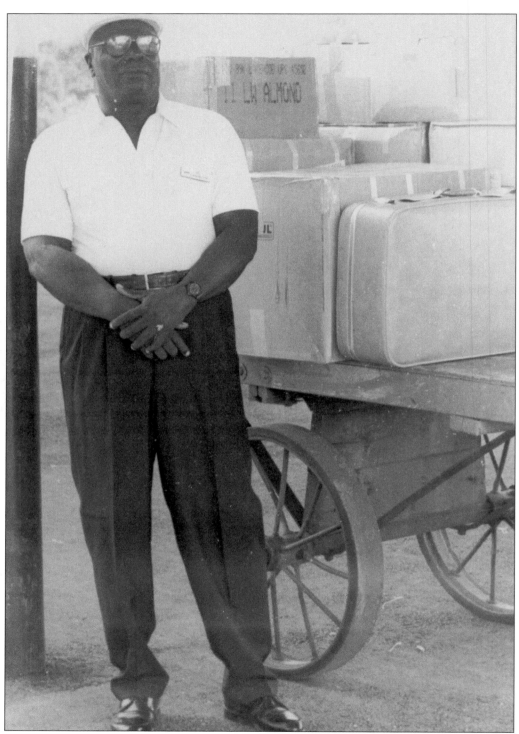

JOE FARRINGTON. Farrington worked for the Seaboard East Coast Railroad as far back as 1952, and served as stationmaster in 1977. This photo of him was taken in the 1960s.

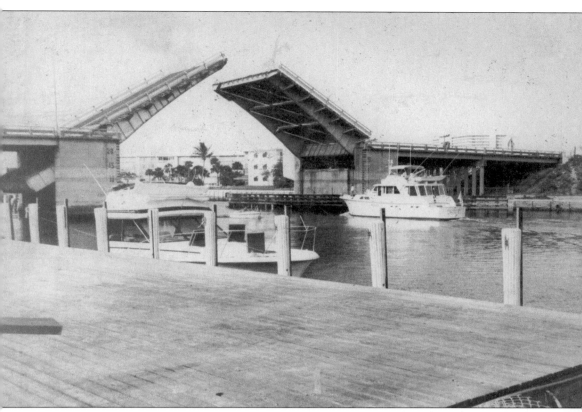

GOING UP! The Butler Bridge is going up to let boat traffic continue down the intracoastal waterway. It is a scene that is familiar even today.

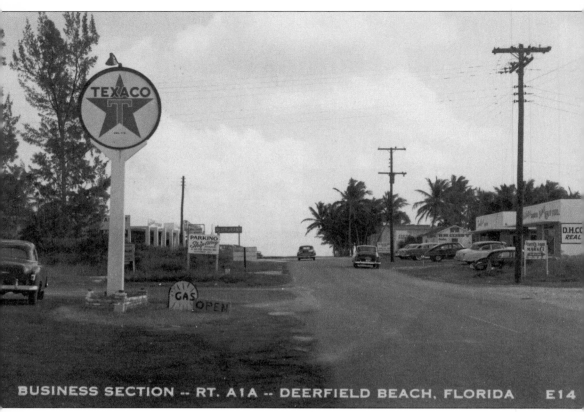

BUSINESS SECTION -- RT. A1A -- DEERFIELD BEACH, FLORIDA E14

RIDING ALONG A1A. The business section of A1A on Deerfield Beach is seen here in the 1960s.

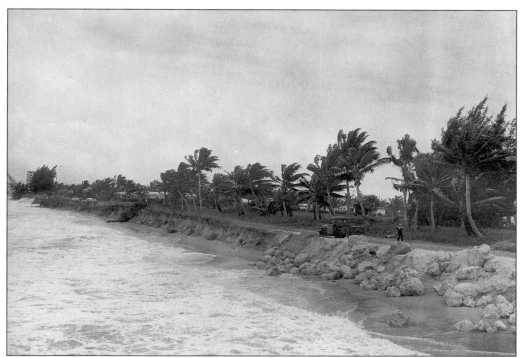

CRUISING ALONG THE BEACH. A pick-up truck cruises along the beachfront road on Deerfield Beach in the 1960s.

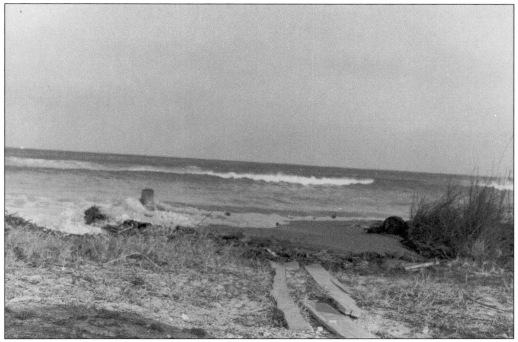

EARLY BEACHFRONT. Pictured here, c. 1960, is Deerfield Beach's original state before it was developed.

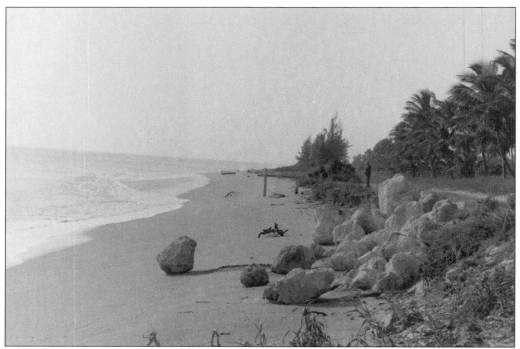

ALONG THE BEACH, C. 1960. Here is another photograph showing Deerfield Beach before it was developed.

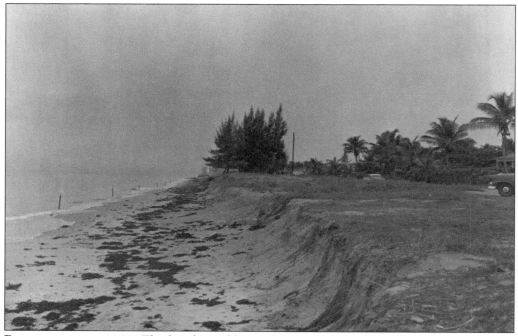

BEACHFRONT, C. 1960. The beach would soon become a destination for many tourists, and the development of the beach would become very important to the city over time. This view looks south.

THE BEACH. Note the boulders, or "rubble mounds," along the beach in this 1960s photograph. These were used, along with a groin and post system, to stop the beach erosion. It was an innovative solution. The waves would break over the boulders, then the groins and posts would capture the sand, which was then deposited on the beach instead of being swept back out with the ocean current.

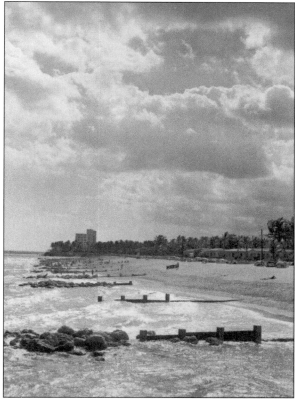

BEACH CONSERVATION. Pictured here is the building of the rubble mounds, groins, and posts that would help to save Deerfield's beachfront.

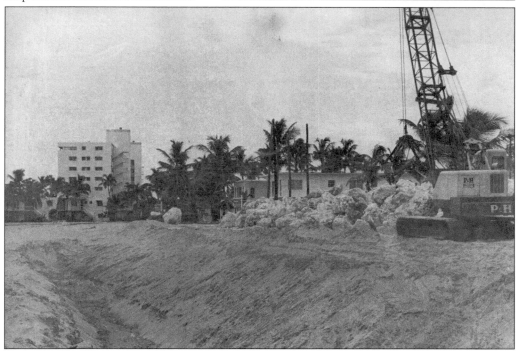

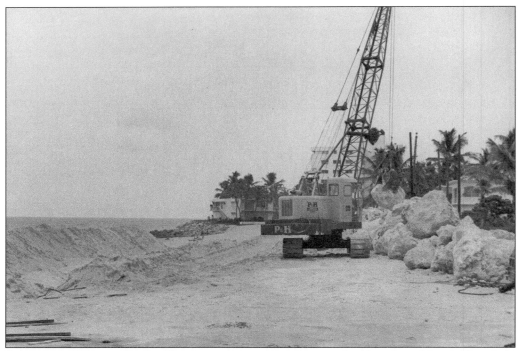

SAVING THE BEACH. The beach conservation project that was developed would make Deerfield Beach a top destination on Florida's Gold Coast.

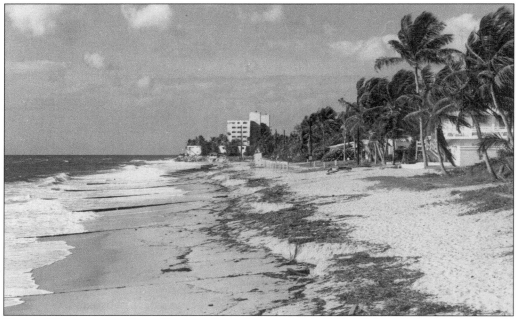

THERE WILL ALWAYS BE A BEACH. Over the years, the width of the beach along Deerfield Beach's oceanfront has changed depending on the tides and storms that hit the coast. Thanks to the conservation system developed in the 1960s, it will always be a beautiful place for tourists and residents to visit.

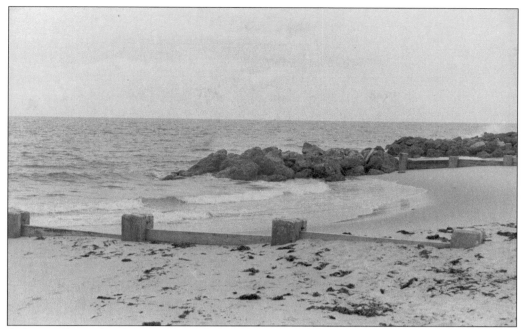

A GREAT IDEA. City Manager Marriott and city commissioners met with Senator A.J. Ryan Jr. who pledged to help Deerfield rebuild its shore. Deerfield Beach's beach conservation project was innovative and helped the community become a top vacation stop in South Florida. The project cost $542,200.

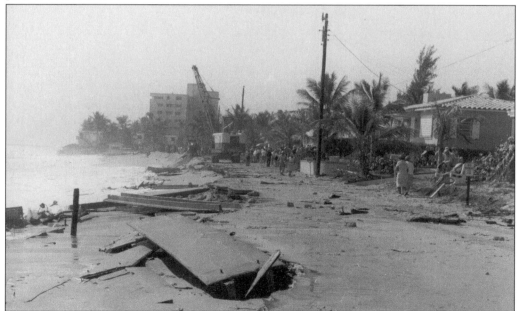

BEACHFRONT DAMAGE. After a hurricane hit Deerfield in November 1962, there was a lot of damage along the beachfront. The pier was derelict therafter until it was torn down by Bill Keitt, an African-American entrepreneur who owned a garage and, for $700, completed the job with his wrecker, a chain saw, and some wrecking bars.

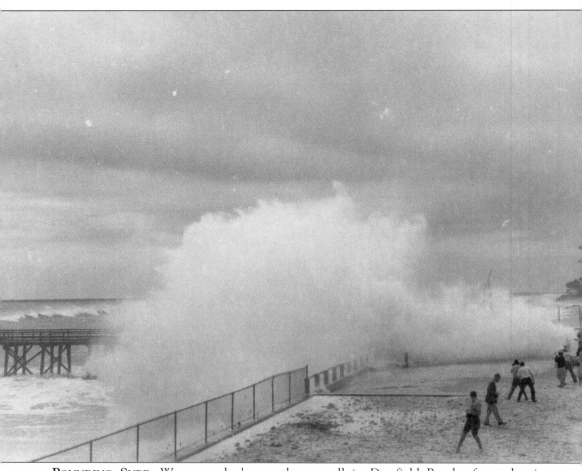

POUNDING SURF. Waves crashed over the seawall in Deerfield Beach after a hurricane came ashore. Deerfield's beach experienced great difficulties due to erosion, and some streets were lost permanently to the Atlantic Ocean.

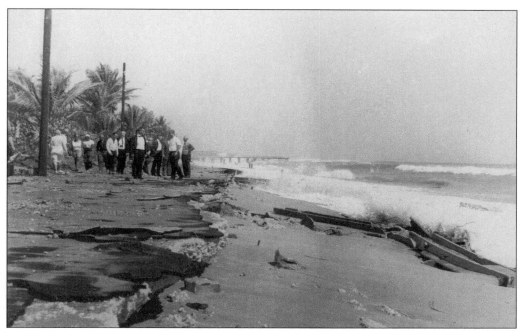

THE AFTERMATH OF A HURRICANE. Some of the beachfront damage that occurred after a hurricane hit Deerfield in the 1960s is visible here. Damage from storms ranged from the Northeast Fourth Street to Southeast Fourth Street areas.

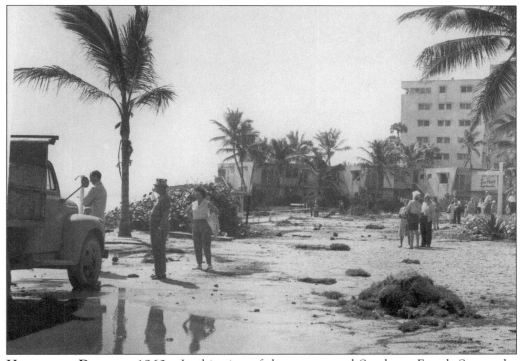

HURRICANE DAMAGE, 1960S. In this view of the area around Southeast Fourth Street, the Cove Beach Club is in the background

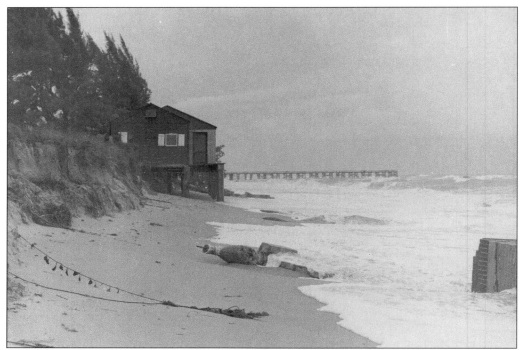

LIVING BY THE SHORE. A house stands on stilts on Deerfield Beach as heavy surf comes ashore in this photograph taken after the hurricane. The heavy surf washed away the sand that used to be under the house.

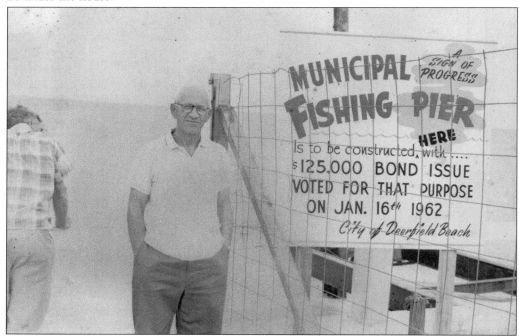

PIER CONSTRUCTION BEGINS. An unidentified resident stands next to a sign that announces the construction of the new Deerfield Pier in 1962.

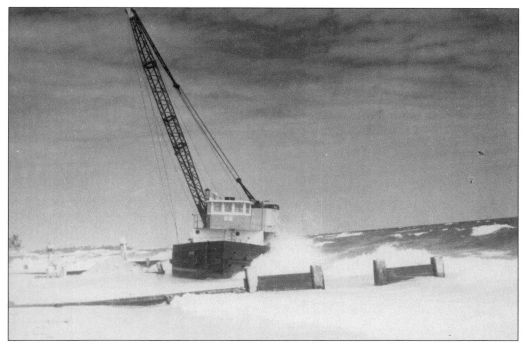

STORM BLOWS. A storm in November 1962 caused barges to drag anchor and come ashore while construction of the new pier was in progress. The pier had been destroyed in the hurricane earlier that year.

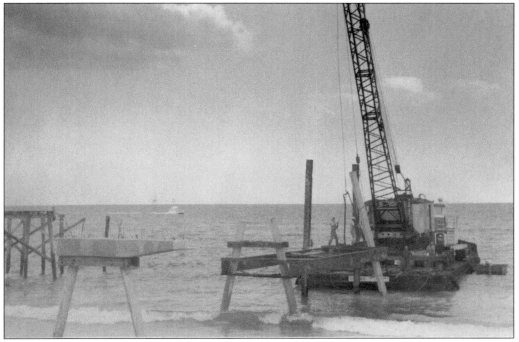

REBUILDING THE PIER. This view shows workers building the new pier on Deerfield Beach in 1962.

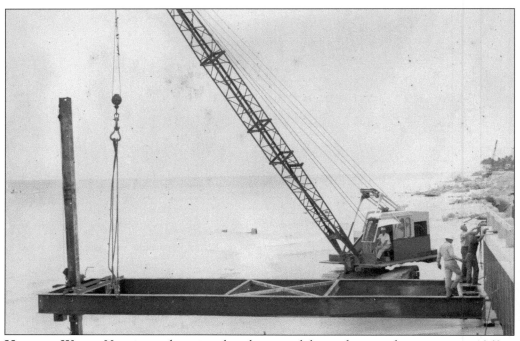

HARD AT WORK. Here is another view that shows work being done on the new pier in 1962.

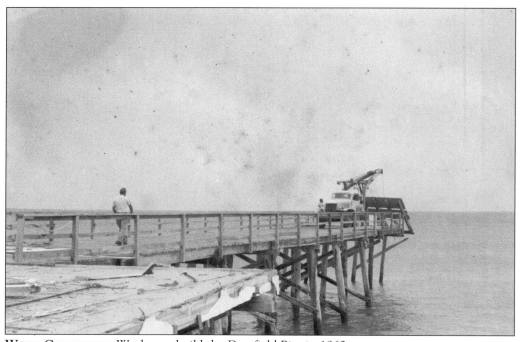

WORK CONTINUES. Workers rebuild the Deerfield Pier in 1962.

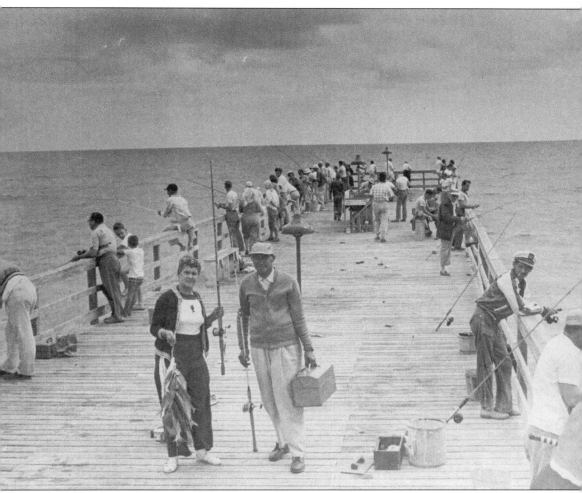

FISHING ON THE PIER. With the pier rebuilt, residents of Deerfield and visitors could once again enjoy a day of fishing in the 1960s.

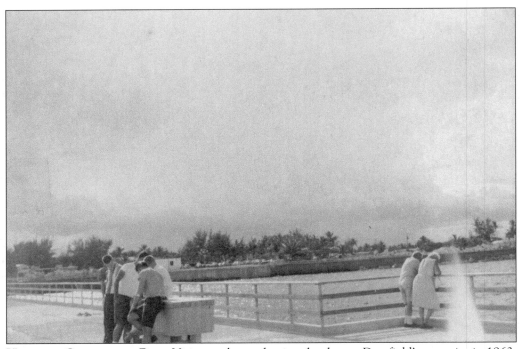

HANGING OUT ON THE PIER. Visitors relax and enjoy the day on Deerfield's new pier in 1963.

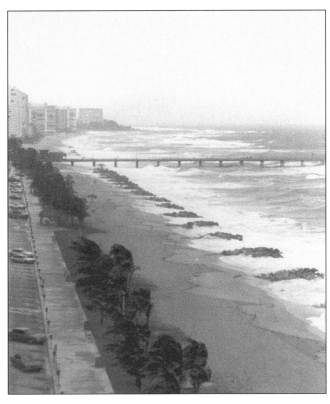

DEERFIELD BEACH. This view along the beachfront looks north from the south part of the beach, towards the new pier.

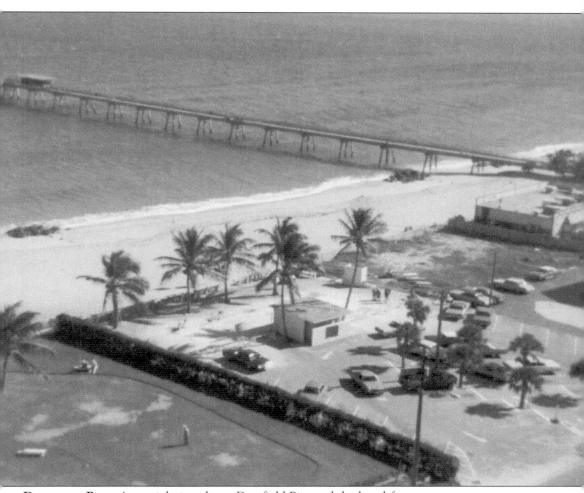

DEERFIELD PIER. An aerial view shows Deerfield Pier and the beachfront.

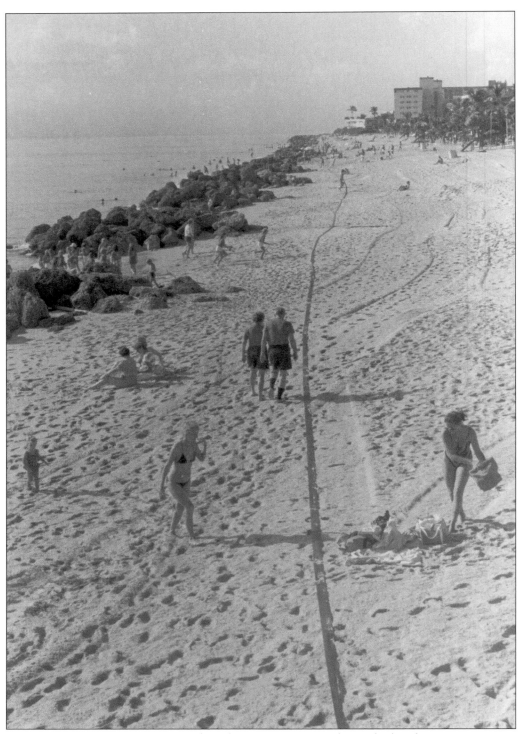

A DAY AT THE BEACH. Visitors and residents enjoy a sunny day at the beach.

Seven

1960–1969

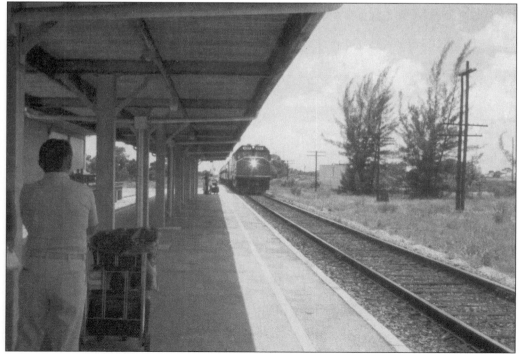

A Train Comes to Town in 1976. As one has done since the early days of Deerfield Beach, a train pulls into the Seaboard Railroad Station bringing visitors, family, and friends to town.

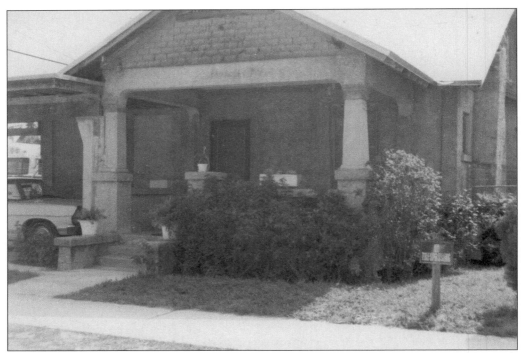

CELEBRATING HISTORY. As part of the bicentennial celebration, the Deerfield Beach Historical Society took note of some of the old buildings that were still standing in 1975. The next ten photographs, beginning with this one, are the buildings that remained at that time. This photo is of the Valdans Howard residence, which was built in 1933.

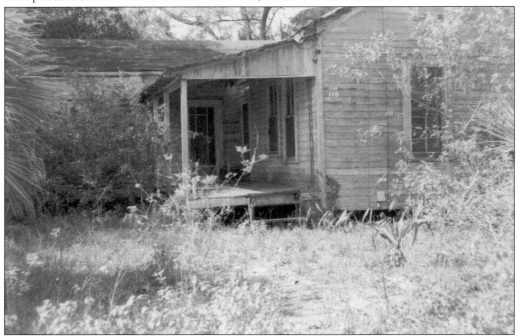

VINA GOULD RESIDENCE. This home was built in 1925 on Northeast Twenty-first Avenue.

THE ROBINSON RESIDENCE. Built in 1908, the Robinson residence (both above and below) was the oldest building left in Deerfield at the time of the bicentennial. The Robinsons lived there until 1940. It was then sold to Lottie Ewald, who lived in the home until 1975. The house, which stood on Hillsboro Boulevard, just east of Dixie Highway, was destroyed by fire in February 1977.

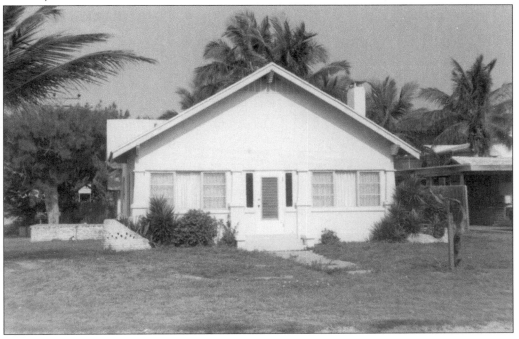

BRANNON'S ROOMING HOUSE. This structure was built in 1917 on South Dixie Highway.

CARLTON RESIDENCE. This home was built in 1910–1911 on Hillsboro Boulevard and Second Avenue.

FIRST BAPTIST CHURCH. The church was built in 1932 on Northeast Second Avenue.

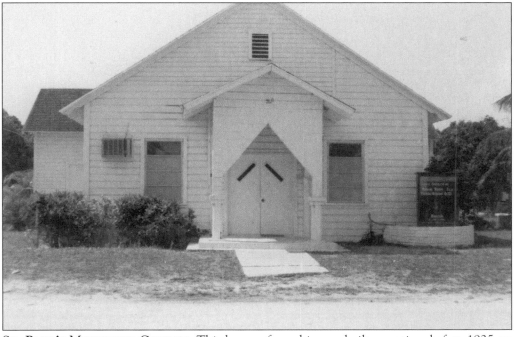

ST. PAUL'S METHODIST CHURCH. This house of worship was built sometime before 1925 on Northeast Second Avenue.

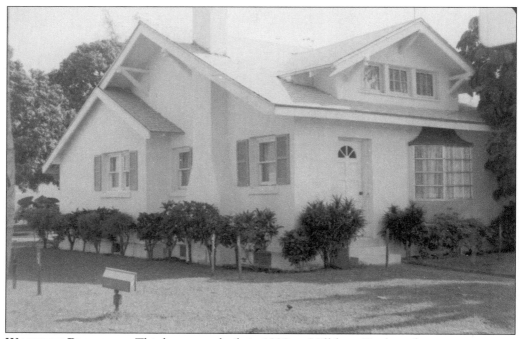

WALDRON RESIDENCE. This home was built in 1920 on Hillsboro Boulevard.

BUTLER HOUSE. Originally located on the southwest corner of Hillsboro Boulevard and Southeast Fourth Avenue, this home was built in 1923.

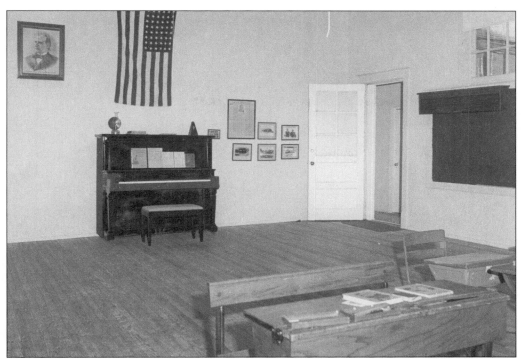

TWO VIEWS OF THE 1920 SCHOOLHOUSE. Built in 1920, the schoolhouse was placed on the National Registry of Historical Places. It was saved from demolition in 1976 by the Deerfield Beach Historical Society.

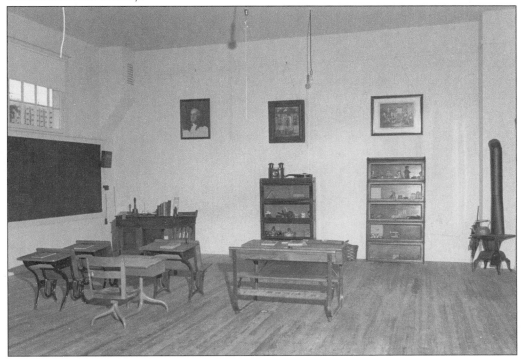

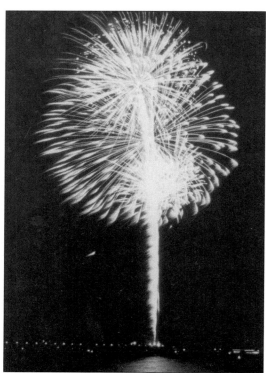

THE BICENTENNIAL. Spectacular fireworks were just a small part of Deerfield Beach's bicentennial celebration on July 4, 1976.

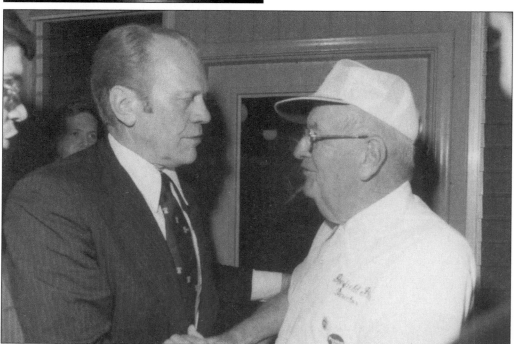

PRESIDENT FORD VISITS THE PIER. On February 28, 1976, President Gerald R. Ford visited the City of Deerfield Beach. In this photograph, Deerfield resident and pier operator Charlie Thompson greets President Ford on his arrival at Deerfield Beach Pier.

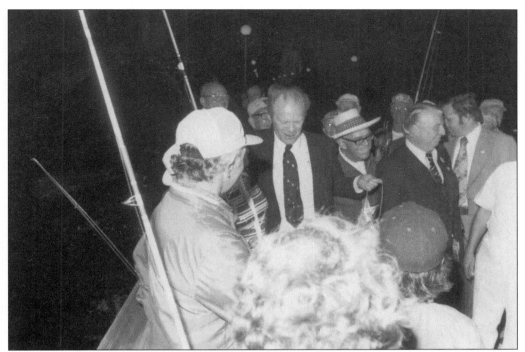

MEETING THE RESIDENTS. President Ford meets some of Deerfield Beach's residents at the Deerfield Beach Pier.

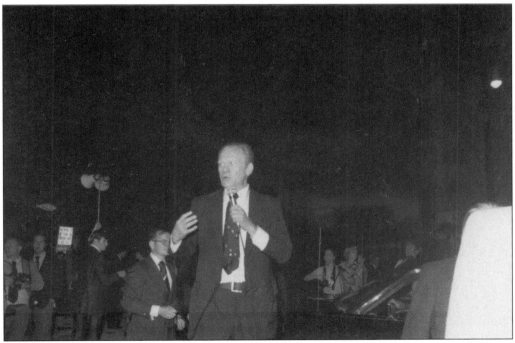

MAKING A SPEECH. President Ford makes a speech at the Deerfield Beach Pier.

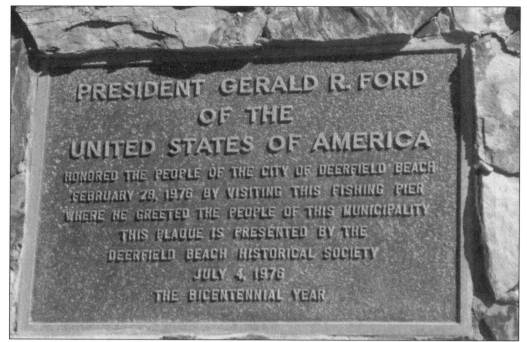

COMMEMORATION. A plaque commemorating President Ford's visit to Deerfield Beach now stands at Sullivan Park.

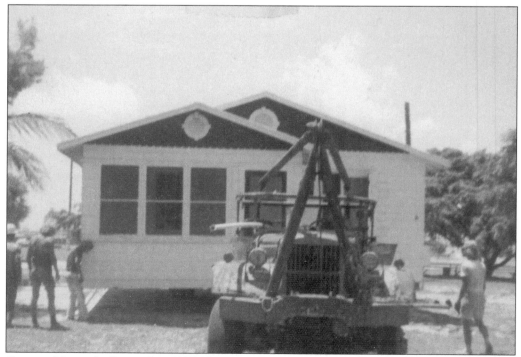

ON THE MOVE. In September 1974, the Kester Cottage was moved from Kraeer Funeral Home to Pioneer Park.

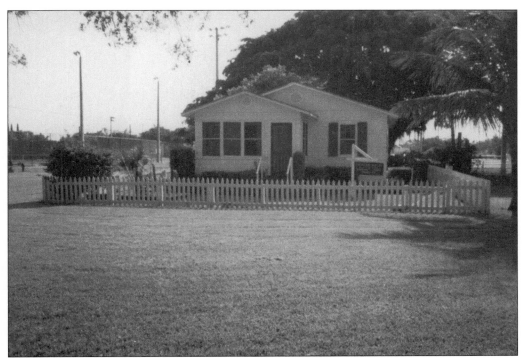

KESTER COTTAGE. The Kester Cottage, or "Pioneer House," is seen standing at its location in Pioneer Park in the 1970s.

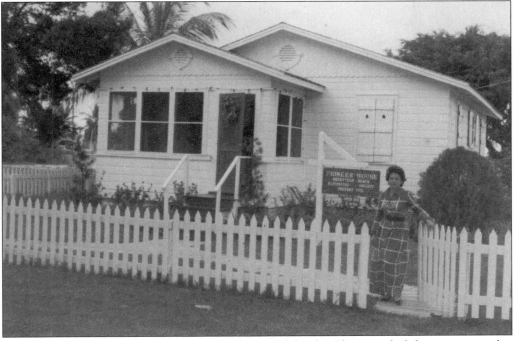

'TIS THE SEASON. The Kester Cottage was decorated for the Christmas holiday, as seen in this photo from December 14, 1975. Juli Brugnoni stands out front to greet visitors.

PIONEER PARK. The park is seen here in 1975.

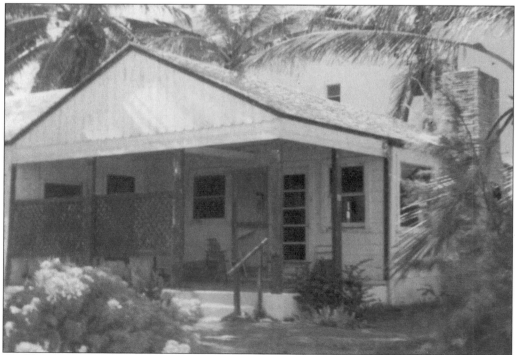

THE CLARK HOUSE. This photograph shows the Clark House, which stood on A1A until it was bulldozed in 1975.

Eight

1980–1989

DEERFIELD ISLAND PARK. After many years in the making, the park, formerly known as Capone's Island, opened in 1980.

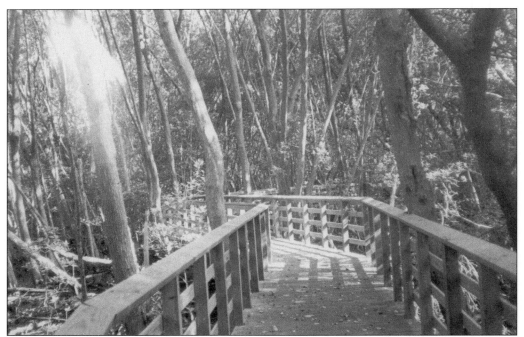

PRESERVING NATURE. Visitors can enjoy a walk through nature in the park.

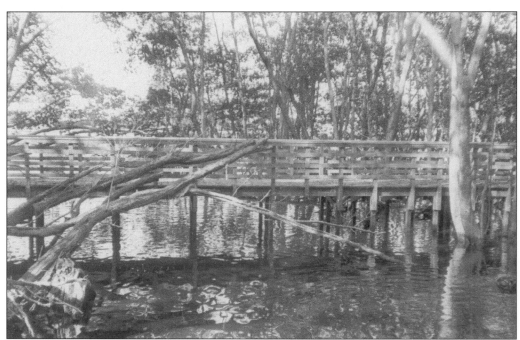

ENJOYING THE VIEW. Trails and walking bridges are scattered throughout the park so that visitors can walk around and enjoy the views at close range.

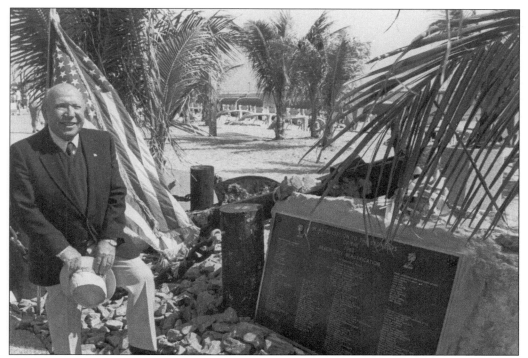

A City Leader. One of Deerfield Beach's leaders and commissioners, Joseph Tractenberg, is shown here at a benefit for one of the city's beautification projects.

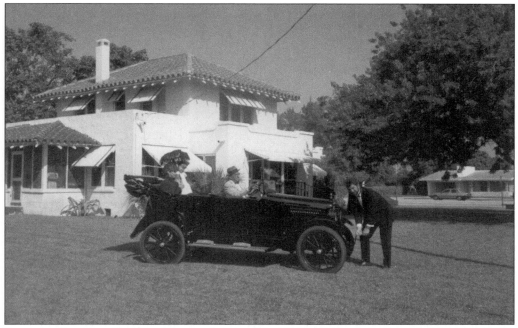

Fashion Show at Butler House. On April 2, 1989, a fashion show was held at the Butler House. Pictured in the car are Kim Reynolds (in the back seat), Ellen Guenther (child), Charlie Maloof (in the driver's seat), and Ed Dietrich (winding the crank).

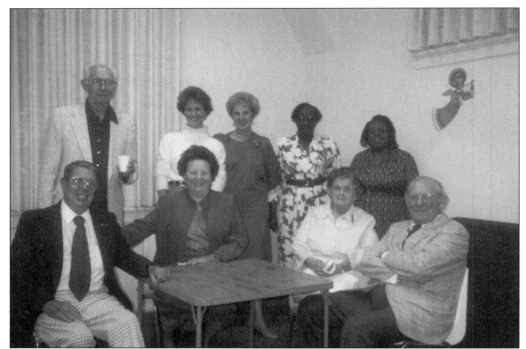

MERRY CHRISTMAS #1. The 1989 Christmas Progressive Dinner at the 1920 schoolhouse was hosted by the Deerfield Beach Historical Society. From left to right are (seated) E.F. Hoisington, Charlotte Floyd, Gladys Hoisington, and Julian Floyd; (standing) Odas Tanner, Barbara Briggs Guenther, Connie Duncombe, Mae Campbell, and Sylvia Knowles.

MERRY CHRISTMAS #2. Here is another photograph showing the 1989 Christmas Progressive Dinner at the 1920 schoolhouse. From left to right are Dottie Rogers, Rosamond and Kenneth Howe, Veronica Nadler, Marjorie Henneman, and Sara Johnson.

MERRY CHRISTMAS #3. From left to right in this photo from the 1989 Christmas Progressive Dinner are Marjorie Henneman, Cynthia Briggs, and Odas Tanner.

MERRY CHRISTMAS #4. This photograph of the 1989 Christmas Progressive Dinner at the 1920 schoolhouse includes, from left to right, Fred Henneman, Mary and Dick Mowry, and Ed and Emily Dietrich.

THREE GENERATIONS. Pictured here are three generations of Ardena Horne descendants. From left to right are Debbie Richardson, Sue Horne Archer, and Gloria Archer Richardson. The child is unidentified, but probably related, which would make it four generations in this photo.

A CHALKER FAMILY PORTRAIT. Barney "Ed" Chalker Jr. is the second from the left, and to the left is his wife, Amy. On his right is his son Brad, Brad's wife, Holly, and grandsons Eric and Bobby. Standing behind Ed Chalker is his daughter Lanie. (Courtesy of the Chalker family.)

DEERFIELD BEACH ELEMENTARY SCHOOL, 1986. It was the new school in town in 1926 and held two classes of children from the first through eighth grades. The classroom on the second floor was used as the town library. The auditorium, which has since been restored, was used for town meetings and social gatherings. The school now has a staff of 70 and over 900 students. The building is listed on the National Register of Historic Places.

SEABOARD TRAIN STATION. The Seaboard Train Station is seen here as it looked in the 1980s. Built in 1926, the train station was placed on the National Register of Historic Places. It was a produce shipping center, and many farmers from Pompano and Lake Okeechobee rented warehouses there. The Butler brothers shipped boxcar loads of cucumbers, beans, peppers, and eggplants to Chicago and New York.

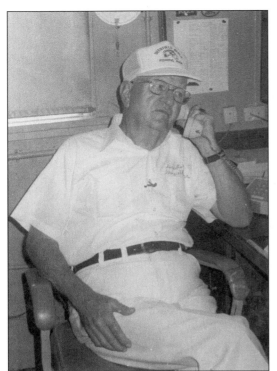

"MR. PIER." Charlie Thompson was the lesee of the "Pantry Pier" from the day it opened in 1963. The pier was open 24 hours a day and saw 300 visitors a day in 1963. Mr. Thompson initiated the slogan "like walking the deck of a huge ocean liner" to describe walking the pier at night. Charlie ran the pier for over 20 years and was proud of the presidential tie clip given to him by Gerald Ford who was on a campaign visit to the pier in 1976.

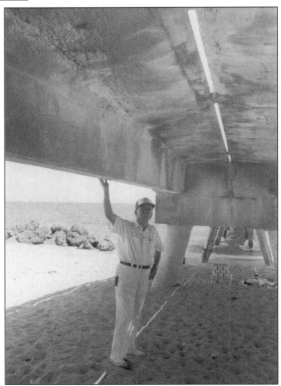

UNDER THE PIER. Charlie Thompson inspects the pier on September 11, 1980.

Ten
1990–PRESENT

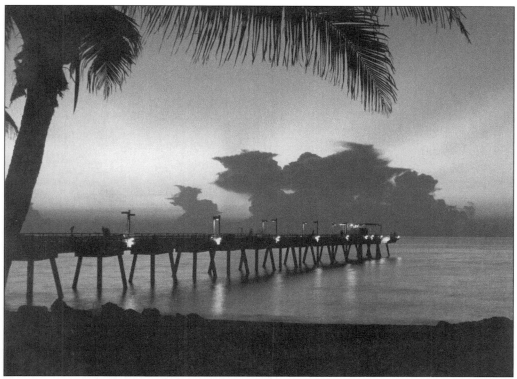

DEERFIELD PIER AT NIGHT. This photograph shows the Deerfield Beach Pier, one of the city's landmarks, on a quiet night along the beachfront.

A GREAT DAY AT THE BEACH. A typical day on Deerfield Beach has residents and visitors enjoying the bright sunshine and comfortable weather.

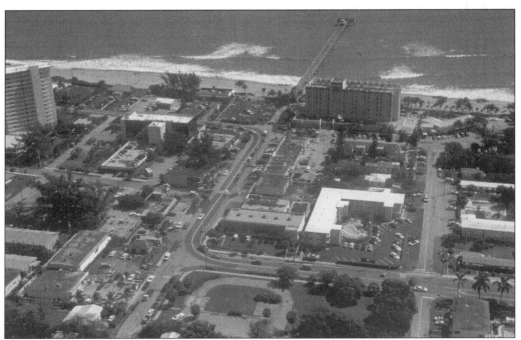

BEACHFRONT AND THE PIER. A beautiful aerial photograph highlights Deerfield Beach.

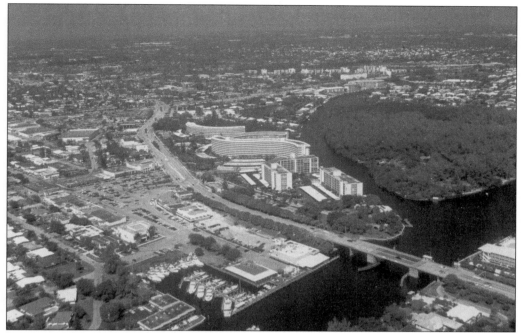

DEERFIELD BEACH AND DEERFIELD ISLAND PARK. An aerial view shows Deerfield Beach and Deerfield Island Beach Park (shown on the right side of the photo), formerly known as Capone's Island.

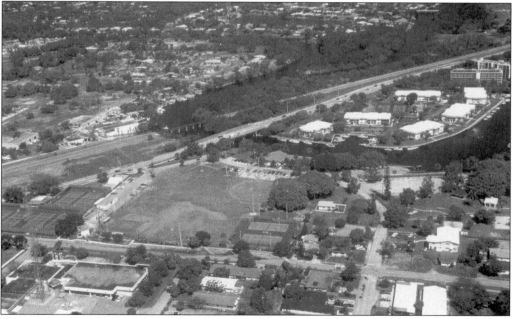

PIONEER PARK. This aerial view shows Pioneer Park, which was funded by the Lions Club. The group held chicken and rib barbecues to raise money for the park and other community projects. Barney Chalker was president of the Lions Club in 1947–1948; Jack Butler held the post in 1948–1949. The barbecues became so popular that they are still held today.

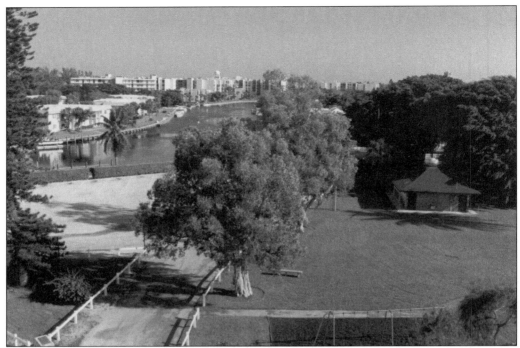

A GLORIOUS DAY IN THE PARK. This photograph was taken on a beautiful day at Pioneer Park.

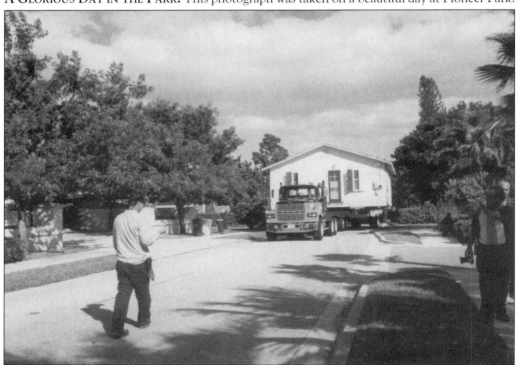

ON THE MOVE AGAIN. Moving Kester Cottage from Pioneer Park to its current location next to the Butler House took place near the end of 1999.

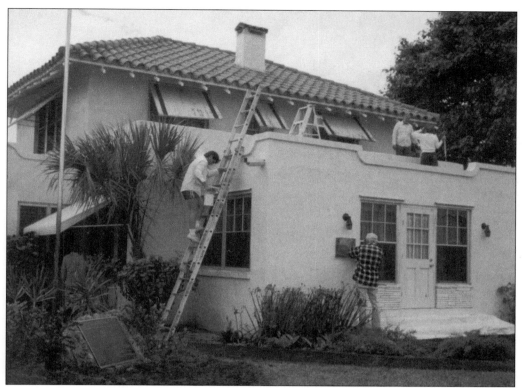

SPRUCING UP. In February 1992, the Butler House was freshened up with a new coat of paint, among other things. Ed Dietrich is shown cleaning the sign on the front of the house.

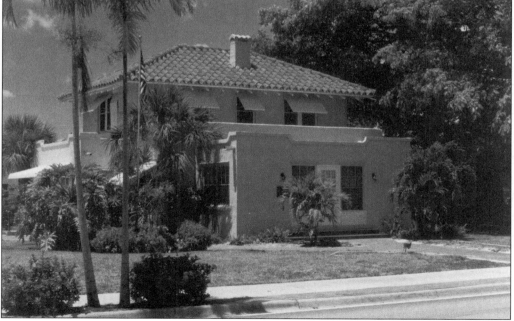

THE BUTLER HOUSE. This view of the Butler House was taken from Hillsboro Boulevard.

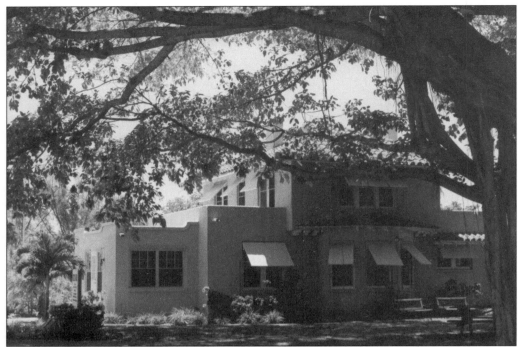

COOL AND SHADY. This view shows the backyard at the Butler House. There were many days when the family would enjoy the shade provided by the giant banyan tree that stood out back.

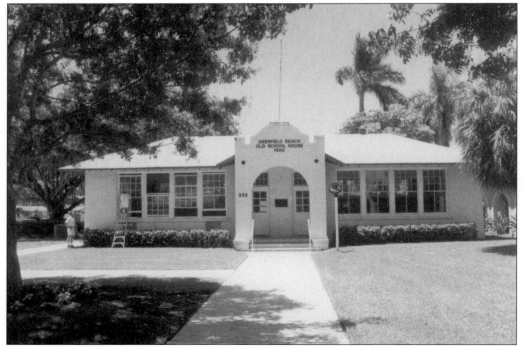

THE 1920 SCHOOLHOUSE. The first schoolhouse in Deerfield Beach had two rooms and is located where the city hall now stands.

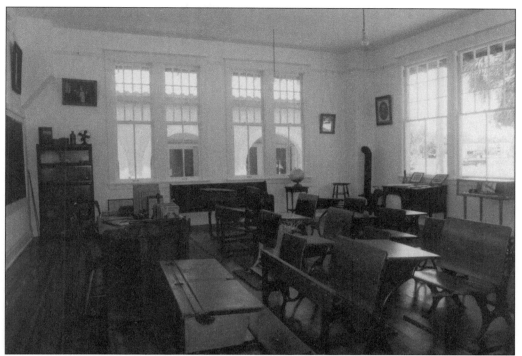

CLASS IS IN SESSION. The interior of the 1920 schoolhouse is seen here as it currently looks, after refurbishing.

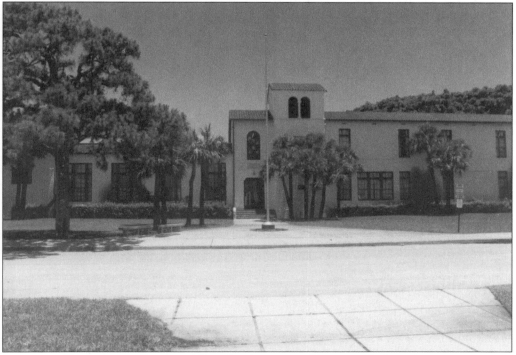

DEERFIELD ELEMENTARY SCHOOL. The school is pictured here as it looks today.

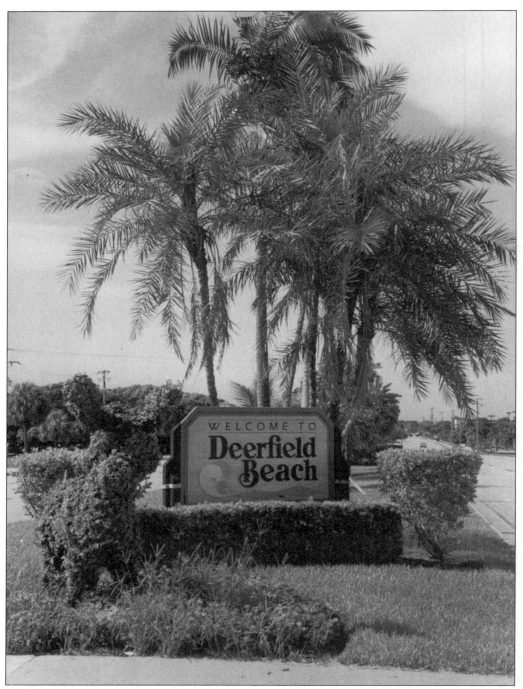

WELCOME TO DEERFIELD BEACH. What better way to end our journey through the history of Deerfield Beach than to extend an invitation to you and your family to come visit this wonderful seaside resort on the southeast coast of the great state of Florida. You are all welcome to come visit any time, and we are sure you will enjoy your stay!